The Artist's World
in Pictures

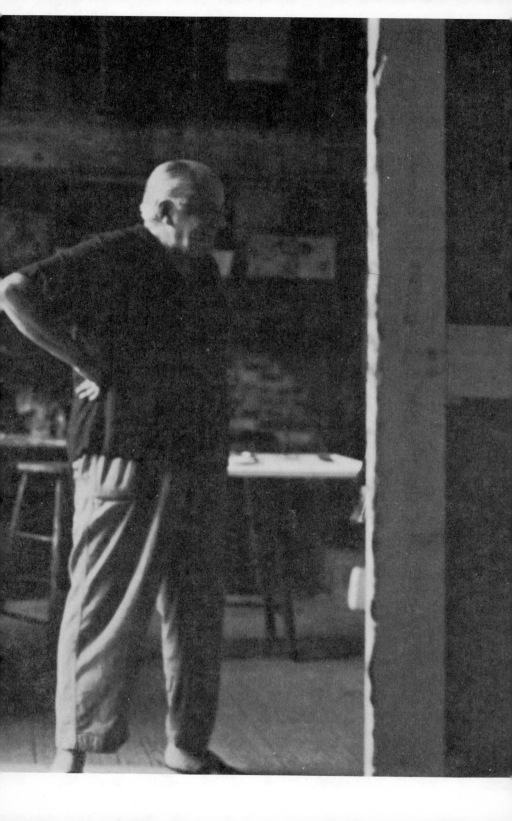

THE
ARTIST'S
WORLD
In Pictures
The New York School

BY FRED W. McDARRAH
with text by Gloria S. McDarrah
Introduction by Thomas B. Hess, Executive Editor, *Art News*

Shapolsky Publishers, Inc.
136 West 22nd Street
New York, New York 10011

TO THE ARTISTS
and to
ANITA SHAPOLSKY
who made this edition possible

Fred W. McDarrah made an important contribution to *avant-garde* literature with *The Beat Scene,* published in 1960. A journalism graduate from New York University, he has won a Guggenheim Fellowship in photography as well as two Page One awards from the Newspaper Guild of New York. Author also of *Kerouac & Friends,* and *Museums in New York*, McDarrah has been picture editor of the *Village Voice* since 1959.

Gloria S. McDarrah is senior editor for Prentice Hall Press, Travel Division. Author of *Frommer's Guide to Atlantic City & Cape May*, she also contributed to the editorial development of *The Beat Scene, Museums in New York*, and *Photography Market Place*. A native New Yorker, she grew up in Lebanon, PA, and graduated from Penn State. She also holds a Master's degree in Romance Languages from New York University.

Tom Hess, who died in 1978, began his career as a writer and art critic in New York in 1946. Editor for many years of the influential *Art News*, he later joined the Metropolitan Museum. He was the author of *Abstract Painting, Background and American Phase* (1951), the first book to treat the new American painting seriously, and of *Willem deKooning* (1959).

Copyright © 1988 by Fred W. McDarrah and Gloria S. McDarrah

Library of Congress Catalog Card Number: 88-042845
ISBN: 0-944007-20-1

Printed in the United States of America

First Edition: November 1961
Second Edition: May 1988

Cover design by Ann Twomey

Cover: Perched on ladder, Norman Bluhm, with a vigorous left-hand thrust of paint, is thrown off balance. Canvas and entire wall are splattered.

Page 1: The clean-up—coffee cans, turpentine, and rags (Studio of J. Mathews).

Page 2: Hans Hofmann in his Provincetown studio.

NOTES ON THE NEW EDITION

Both Gloria and I arrived on the art scene right after Jackson Pollock drove his car into a tree in East Hampton in August of 1956. Our first encounter with the New York School was at The Club panel discussion that November on East 14th Street where the topic was Pollock's legacy to the art world. It was a momentous evening. We were among the art giants of our time: Bill deKooning, Franz Kline, Fritz Kiesler, Clement Greenberg, Barney Newman, Harold Rosenberg, James Brooks and dozens of others. Here were the artists who had survived the Great Depression, worked for the WPA, fought World War II — it seemed they had paid more dues than any other generation.

Our mentor in the art world was William H. Littlefield, a Boston-born painter who had been in Paris in the 1920's and studied with the legendary Hans Hofmann in Provincetown. Bill provided a unique opportunity for us outsiders to view the inner workings of the art scene. When Littlefield became The Club administrator, taking attendance and folding chairs after the meetings, I was his assistant. The Club guru, Philip Pavia, allowed me to occasionally take a few photos which he later published in his historic *It Is* magazine. These were the first pictures I ever published.

It was a unique period when all the avant garde came together — painters, sculptors, composers, musicians, choreographers, poets, architects, critics — to collectively confront the establishment and to demand acceptance on its own terms. We were attentive listeners and eager learners. I knew something important was happening, and instinctively wanted to photograph it all.

Gloria and I went to art openings, parties, artist's studios, Club meetings and symposia and eventually accumulated a stack of snapshots. Writer Seymour Krim suggested taking my work to Cyril I. Nelson at E.P. Dutton. He saw its value and published *The Artist's World* in 1961.

The book was never intended to be an "art book" or a record of every New York artist. Instead, it aimed to show who was on the scene and what it was like to be a struggling artist. This new edition, with a few additions, is an exact re-issue.

It's obvious that time has been good to some of these artists, and bad to others. While some of the Abstract Expressionists never achieved major recognition, others have reaped the fruits of their labors and have placed their works in museums all over the world. Long gone is the gallery-packed 10th Street we knew in the 1950's; now the street is cluttered with high-rise condos. The Club and the old Cedar Tavern vanished when Franz Kline died in 1962.

In the late 60's and 70's the New York School took a back seat to subsequent art movements—Pop-Art, Op-Art, Minimal Art, Conceptual Art, New Realism, Graffitti, Performance Art and, alas, Cartoon Art. But now as we approach the 90's it seems we have come full circle, and renewed interest in the New York School calls for a re-issue of this classic work.

Fred W. McDarrah
May 1988

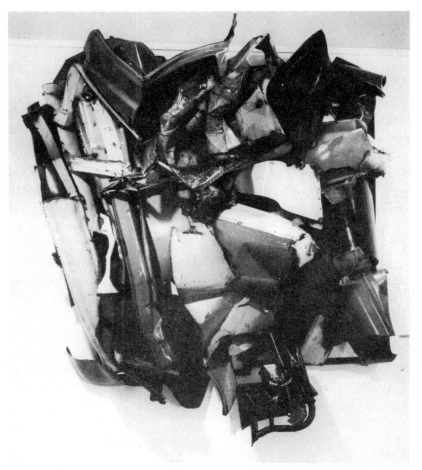

John Chamberlain's recent work, "Essex" (1960), is a polychrome metal wall relief. It measures 108″x90″. Photograph by Rudolph Burckhardt, courtesy of Leo Castelli Gallery.

CONTENTS

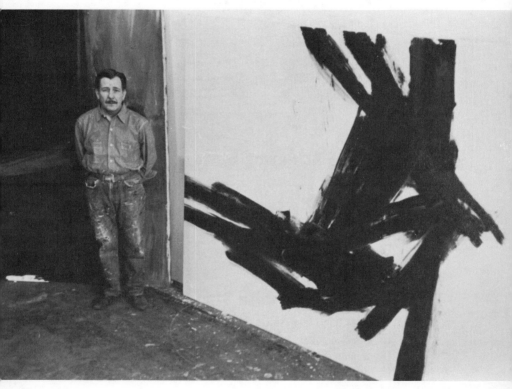

Franz Kline in his 14th-Street studio.

INTRODUCTION

Fred McDarrah's dedicated book of photographs is a reflection of the community of artists in New York City and environs that has produced, since around 1945, and is continuing to produce, the most vital cultural force in the world today: Abstract-Expressionist art, or Action Painting, or the New York School — however you want to name it.

It is an untitled Style because it has no single, common style. Rather there has been a series of brilliant, connected, individual visions that have revolutionized art and exploded styles in the most profound sense — it has given to painting and sculpture a whole new history and a whole new view of the past.

New York painting has an international influence, but it is always easy to distinguish the original product from its Parisian, Italian, Japanese, or Polish versions. There is a local "Look," a light; Harold Rosenberg has called it the "unfinished, hairy" aspect. It has, as Willem de Kooning said, a "smell of raw concrete" about it, and of rubble: the body-odor of a city where anonymous tin-and-stucco edifices are ripped down and equally anonymous glass-and-aluminum monsters shoot up daily.

Matisse said, "New York has the clear, saline air of Venice."

Franz Kline said, referring to a particularly endearing bit of downtown loft-building-cum-retail-outlet with a hundred-foot neon sign advertising "The American Doll Co.," "It's so beautiful it breaks your heart."

Fred McDarrah has caught much of this look, aroma, feel, and light of New York art in the thousands of photographs he has taken of artists in their studios, of their parties and dead-pan symposia, their streets and galleries, their passionate friends and a few peculiar enemies. A selection of over three hundred prints makes up this book.

The sense you get from them of a ball at the lip of a volcano is real; the grinding poverty is also very real. No society (except perhaps the Parisian nineteenth-century horrors celebrated by Balzac) has been as cruel and as viciously indifferent to its best artists as ours.

To be an American artist who is seriously involved with vanguard ideas today means to be attacked by almost the entire Establishment — mass-circulation newspapers and magazines, museums, collectors, critics, official culture-rollers. If, after fifteen or so years of dedication, the painter or sculptor has not been driven off his rocker, or back to his successful cousin's rug business, or into the coy bureaucracy of a Midwest university, he might (with a little teaching on the side) find a very modest livelihood in his profession. But he shouldn't count on it.

I reckon that today there are about twenty-five Abstract-Expressionist artists making what any forty-year-old college graduate would call "a living" in New York. The fact that a de Kooning or a Kline or a Hofmann has been able to "come through" is a miracle of the individual's perseverance, courage, ingeniousness, wit, and faith — a miracle which daily is greeted by abuse from practically every spokesman of the "Powers That Be."

This accounts for some of the gray light and sense of tension in McDarrah's incisive photographs. Anxiety floats in the mote-filled air of the lofts. It is behind the baroque bar jokes. It moderates at panels in the artists' Club. It flavors the coffee at Riker's.

The saving grace is gallantry — that forgotten word. And McDarrah has documented this, too, in the faces of his protagonists. Indeed, what characterizes the best of this art is exactly its quality of moral pressure. The statement (or, more usually, the question) is a part of the artist, a fulfillment, an extension of his personality, like his wrist or the timbre and size of his laughter.

A community exists by loyalties; great art lives off lesser artists; artists themselves make an audience; they are true critics and

best interpreters. What has been derided as "a gang" is also the only place where an idea can be formulated.

This is not a book about hermits. A sociologist might even find the deep patterns of a tribal culture in "the scene" (chiefs, witch doctors, the Long House, the inevitable *rite-de-passage*, or Opening — here of a one-man show, of course). But above this communal infrastructure, which was formed in the Depression days of the 1930's, there is the cosmopolitan nature of New York art: its continuation of the great European movements; its sense of the New as the New has been greeted since the Renaissance — with wonder and anarchistic delight; its profoundly antichauvinist, international outlook.

Fred McDarrah came to the scene after the action had begun. Pollock, Gorky and Tomlin were dead. Charles Egan no longer ran the liveliest gallery in town. Three, four, and five more generations had been added to the original two. Tribal subdivisions were formalized. New collectors arrived. Time telescopes, and the scene as it is — as McDarrah has recorded it — almost convinces you that it was always like this. And it is not to McDarrah's discredit that he has photographed only what he was able to see. This is his "present," and the present always tries to gobble up its past. Thus I register here my general objections to certain inclusions and exclusions in this book which, from my point of view, distort my picture of things. But McDarrah can come back and answer, like the Voice in *The Connection*, "This is how it really is."

Fred McDarrah does not claim his photographs are art. He claims they are a part of truth. They are also brilliant (this *is* how it looks). And they have something to do with justice. Here is where I disagree with him violently in places, but also agree so strongly in others that I am writing this foreword.

Perhaps the best way to close my text would be to try to add a bit of written history to his visual chronicle. In the summer of 1954, in East Hampton, Long Island, the artists organized a Saturday

11

afternoon softball game. Phillip Pavia, who had enjoyed the advantages of a regular Connecticut boyhood, was the best batter — a home-run specialist. His friends decided to counter this forte.

A day before the game, Willem and Elaine de Kooning and Franz Kline, who were sharing the Red House, bought two grapefruit and a coconut. They worked until two in the morning sandpapering them and painting them to look exactly like softballs, with all the essential seams, cracks, chiaroscuro, and even a trade label, "Pavia Sports Association."

The next day, when the game was about halfway over, Harold Rosenberg came up to pitch. Pavia was at bat. Rosenberg pitched the first ball. Pavia swung, and it exploded in a great ball of grapefruit juice. There was general laughter and little shouts of, "Come on, let's get on with the game."

Esteban Vicente came in from behind first base (where Ludwig Sander was stationed with a covered basket containing ammunition); he pitched his first ball over easily. Pavia swung. There was another ball of grapefruit juice in the air. More laughter. Finally they decided that fun was fun, but now to continue play, seriously. Rosenberg came back to the mound. He smacked the softball to assure everyone of its Phenomenological Materiality. He pitched it over the plate. Pavia swung. It exploded into a wide, round cloud of coconut. "Look, look," shouted Pavia, as if he had always suspected that if you hit a baseball hard enough to break it, there would be coconut inside. Then, from nowhere, a crowd of kids appeared around home plate and began to pick up the fragments of coconut and eat them. They had to call the game.

There is no moral to this story. There is a crucial moral to the artist's life. Here is a place to see it.

THOMAS B. HESS

Page 13: Loft studios near the docks of the Fulton Fish Market.

Part 1
A Way of Life

I F, FIVE thousand years from now, the mortal remains of a New York artist were mounted in a museum of natural history, the placard below the figure would surely read: *Homo sapiens, artifex americanus, habitat: "cold water loft."* Today, at least, generalizations about the artist and his work are difficult at best, and predictably inaccurate. But to describe one cold water loft is to describe them all. The conformity in this one respect is astonishing. Yet this should not prove too surprising, since in every case the basic requirements are the same. Let's consider a few.

1 Cold Water Lofts

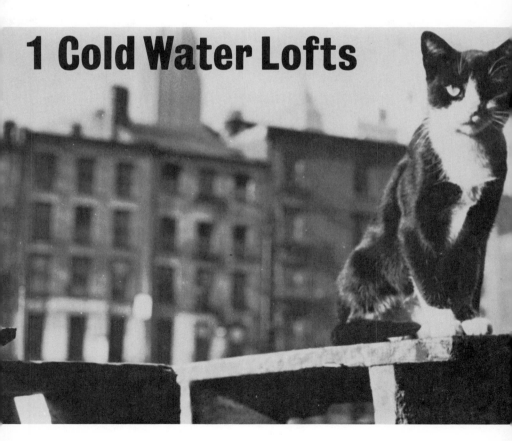

A Broadway loft with total area of 65' x 24'. Easel in foreground is in painting area/ Drafting table in detail at right is used as quick lunch counter. (Georges.)

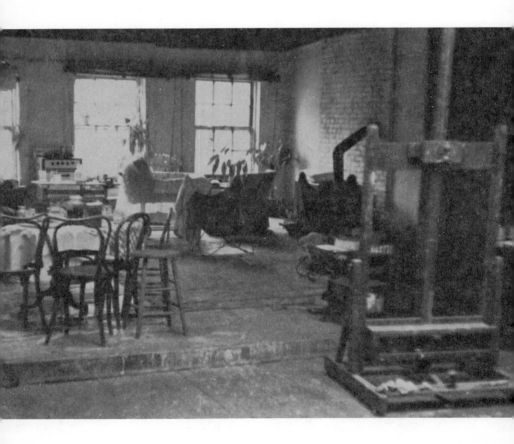

First and foremost is space. In the United States our imaginations have been stretched, probably from the beginning, by the spaciousness of the wilderness, the height of the mountains, the depth of the western canyons. Then came the tallest building, the longest bridge. Now there are the artists, drawn to our greatest city by its excitement and virility, needing immense studios in which to realize the mural-size pictures and room-size sculptures that express their far-stretched American vision. Such painting, such sculpture cannot be created within the confines of the garrets of older days; artists working in New York today need real space.

And space is at a premium. Greenwich Village, once the artists' mecca, is no longer a low-rent haven. What now remains to the artist within the boundaries of the city are the lower East Side, the rundown factory and Hudson River waterfront district around Chelsea, and the East River dock area near the Fulton Fish Market. These are the cheap-rent districts. Here, awaiting the ever-widening reach of the city's real-estate developers, are the turn-of-the-century factory buildings — the lofts. Built specifically for light manufacture and warehousing, the floors of these lofts are free of wall partitions and run from one end of the building to the other. The old-fashioned ceilings are high, and windows run the full height of the room. Usually the top-floor ceiling has a tremendous skylight.

A loft has space and light; it's cheap, and, unfortunately, difficult to find. A young painter, just coming to the city, cannot hope to rent a loft immediately. Since they are so desirable, painters will trade or sell the lofts, but only to friends. Often a loft is passed down from generation to generation. Splatters of paint from the brushes of Arshile Gorky can be found on the floor of a 14th-Street studio still occupied by a painter. A loft like this will probably remain in the artists' world until the building is demolished.

Once he finds a loft, the painter's first step is to whitewash the walls. Since many painters cannot afford to maintain separate liv-

15

NO EMPLOYMENT ABOVE THIS FLOOR
3ᴿᴰ,4ᵀᴴ+5ᵀᴴ FLOORS-3 INDIVIDUAL ARTIST'S STUDIOS
EACH FLOOR LOFT - ONE ARTIST'S WORK SPACE.

NO FACTORIAS ARRIBA DE ESTE PISO

NO SMOKING - NO FUMAR.

Above, sign in hallway of lower Broadway loft building/ Left, Joe Clark building a platform around a mattress for oriental-style sleeping. Raised area also provides additional storage space underneath/ Below, painter Joe Stefanelli in his loft on 22nd Street, formerly occupied by a garment factory.

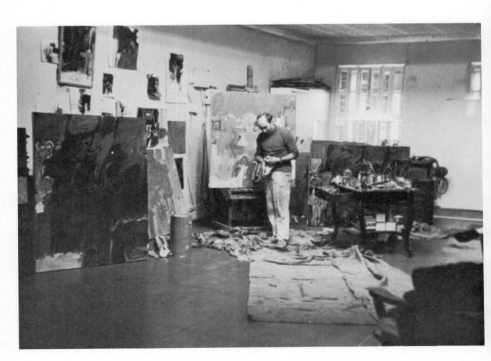

ing quarters, a small portion of the total area will very probably be set aside for living, but three-quarters of the space is reserved for the studio proper. Here, in the work space, whatever money that can be spared is invested in brushes, paints, lumber, and tools.

The whitewashed living area is handsomely decorated with friends' paintings, sculpture, and many other kinds of art objects. The furniture usually consists of a group of secondhand chairs around a low table near the fireplace or stove, a couch, and at least one set of shelves crammed with art books. Somewhere on the walls a board displays various notes, addresses, gallery announcements, old photographs, art reproductions, postcards, newspaper clippings, and other curiosities.

In the partitioned kitchen space, furnishings are strictly utilitarian: an old gas stove, refrigerator, and open shelves for groceries. The shelves are built from egg, orange, or apple crates with no attempt to disguise their origin. Throughout, however, there is a sense of shipshape neatness, with a place for everything in the soft white light.

Actually, the term "cold water loft" is misleading. Many studios have the convenience of heat and hot water provided by the tenant, yet some are still warmed by fireplaces and potbellied stoves. More enterprising artists install bathtubs, kitchen sinks, and intricate plumbing.

With the addition of these "creature comforts" it's easy to appreciate how valuable a loft property may become, but this value is now threatened by New York's rebuilding program for the downtown area. One can only wonder where the young artists will work after the lofts have been demolished.

 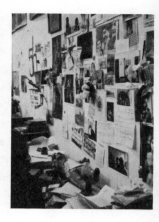

Left, tools used in an artist's studio (Bugeaud)/ Center, storage racks for unsold paintings and work in progress (Pearlstein)/Right, typical artist's bulletin board in studio (Leslie)/ Below, Clark struggling to hang a painting. Heavy wood stretcher and frame alone can weigh 50 lbs.

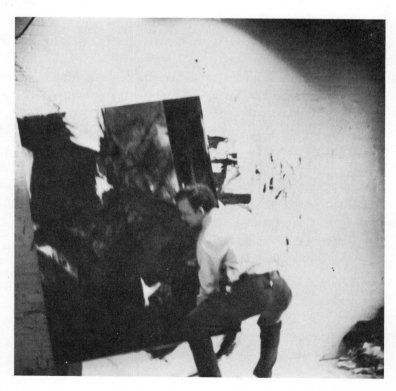

18

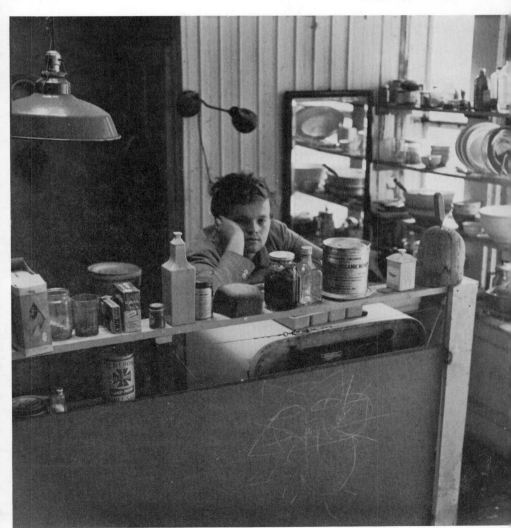

Edward Avedisian, below, leaning on refrigerator behind open shelves of groceries and kitchen equipment. Wooden hat block is legacy from former tenant. Victorian dining table at right is surrounded by piano stools and ice cream parlor chairs. Loft runs full length of building.

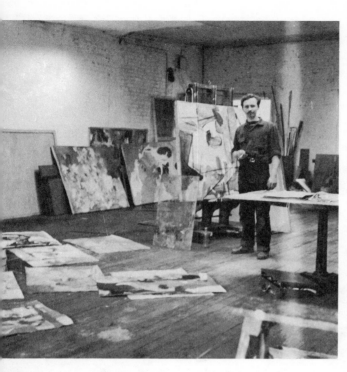

Maurice Bugeaud, above, spreads paintings throughout studio to get an over-all view of work in progress/ Bugeaud, below left, surveys neighboring loft buildings ready for housewreckers.

Robert Rauschenberg, below right, enclosed in kitchen area which has hand basin and hot plate cooking unit.

2 Life in the Country

2. LIFE IN THE COUNTRY

In New York the art season slowly comes to a halt near the end of May as gallery after gallery hangs its annual summer exhibition, not to be changed until the fall. It is in June, then, that the art world seems to disintegrate and the artists desert the city. There will be some who can afford to head for Europe, especially the successful hunters of art fellowships. But the majority look forward to a summer in the country, where they are apt to congregate at such traditional art colonies as Provincetown on the tip of Cape Cod, Woodstock, New York, or East Hampton, Long Island.

Provincetown, for example, has been one of the most popular artists' resorts since the turn of the century. Besides the usual summertime attractions of sea and sand and sky, there are established art schools and galleries, which, incidentally, offer a variety of odd jobs for the young artist needing to earn his summer rent. In addition there is the considerable charm of the town itself, with its ocean-fronting main street lined with many fine old houses built by the early New Englanders. The wide floorboards and sturdy ceiling beams offer a satisfying summer contrast to the New York artist.

Year-round residents of Provincetown (themselves a heterogeneous combination of Portuguese fishermen and old Cape families) tend to look on their unusual summer visitors in much the same way as the residents of a college town view the goings-on at their local university. This "town vs. gown" relationship manages to keep both groups in a state bordering on nervous tension.

Daily life in Provincetown is delightfully casual. If an artist must wait on tables to earn his meals, he'll probably spend some of his free daytime hours painting — out-of-doors if the spirit moves him, indoors if he finds himself distracted by the novelty

Page 21: View of Provincetown, Mass., from the Pilgrim's Monument.

Above, Richard Klix in summertime occupation at HCE Gallery. In city he works in an ice-cream factory/ Above right, builder-architect Henry Rose adding studio unit to house/ Right, Peter Busa School of Art, one of many in art community.

Commercial Street in Provincetown.

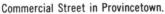

of constantly changing light. Time off for pure relaxing is naturally spent at the beach or on the lovely, lonely sand dunes for which Provincetown is famous. Barren miles of the dunes stretch along the northern end of the Cape. A walk along these dunes presents an unsurpassed opportunity for communion with nature, and it is easy to understand why they have become Provincetown's most durable attraction.

Early in the evening a visit to one of the two or three artists' bars is usually part of the daily schedule. Over a pitcher of beer the summer citizen can watch the new arrivals in town, gossip about the day's happenings, and learn of any special social events scheduled that night. After dinner, if the artist himself is not a gallery sitter he becomes a gallery visitor, and makes the rounds on Provincetown's main street. Near the town pier, brightly lit shop windows offer a variety of handmade jewelry and leather goods, and the usual junky souvenirs. Window-shopping forms part of the evening's promenade, and eventually strolling friends meet "on tour," often to spend the remainder of the evening chatting and drinking together.

On holiday weekends the influx of visitors heightens the summer gaiety. Groups of newly met friends plan late picnics on the beach, and studio parties become grand reunions where news from the city is exchanged for local gossip. One special feature of such a weekend will often be a wildly improbable "pick-up" game of baseball. The artists may not show much talent for the finer points of the game, but what they lack in finesse they more than make up in enthusiasm, relaxation, and sheer good fun. For what could be better than a summer in the country?

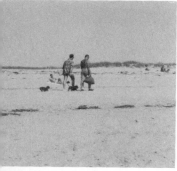

ing to the beach.

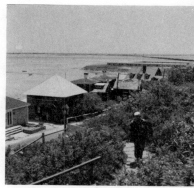

Bayside artists' studios.

Lonely walk on the sand dunes.

Atlantic House, a jazz center, and the Colony, the artists' rendezvous.

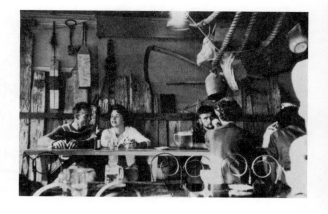

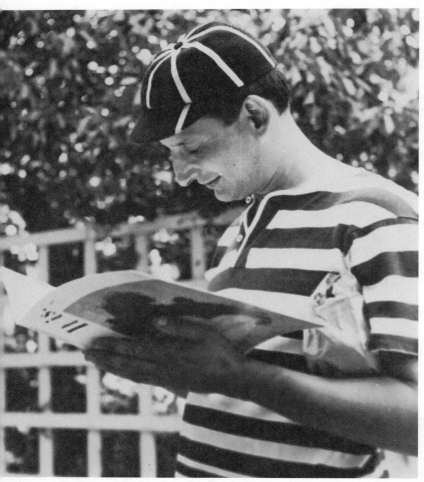

Angelo Ippolito glances through **It Is**, magazine of abstract art delivered to resort by special messenger.

Climate of change in Provincetown. One season building houses gallery run by John and Nicholas Krushenick; next season the 371 Gallery, a showcase for work of Taro Yamamoto.

t citizens of Provincetown, Maria and Hans
nann/ Below left, their sitting room interior/
right, their home with studios in rear.

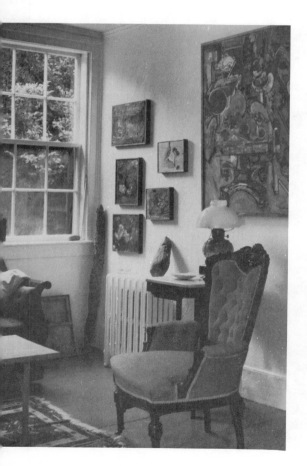

Artists' baseball game.

Choosing sides. Sculptor Sid Gordin with

Breathless pitcher Warren Brandt throws a mean ball.

Home-run champ Franz Kline belts

Third baseman Katz tries to stop the champ.

Cheering section, Bud Wirtschafter and Fi Dawson, wait for the hero.

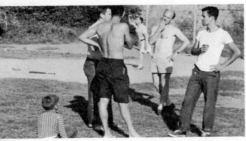

Strategist Gordin and umpire Katz plan next move as Nat Halper searches for ball.

Batboy Sam Feinstein warms up for critica stitute Brandt. Game called on account of (on the muscles).

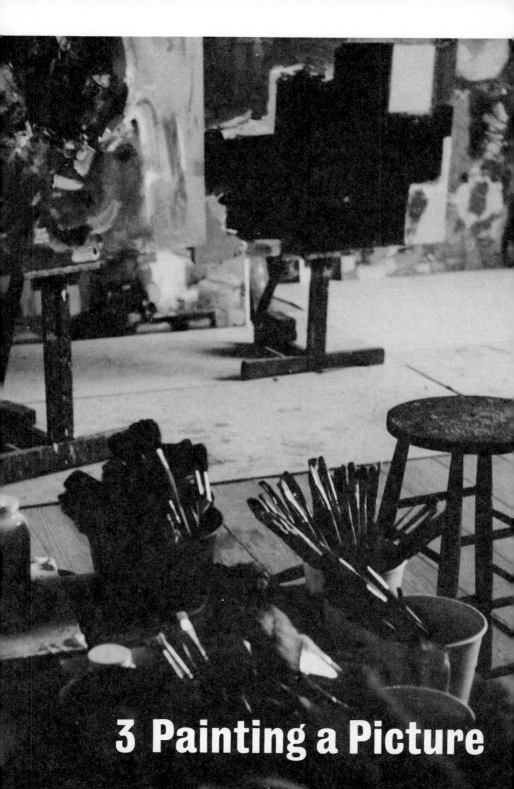

3 Painting a Picture

Above, paint bin, bottles of varnish, turpentine, and linseed oil (J. Mathews)/ Right, palette and brushes ready for painting (Hofmann)/ Below, Lester Elliot with pliers and staple gun stretching six-foot canvas in studio.

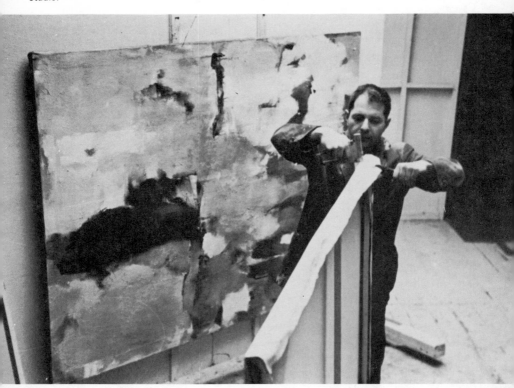

3. PAINTING A PICTURE

In order to paint a picture there must be paint, and canvas to paint upon. And brushes. And turpentine and oils to lighten a color, or thin the paint, or clean the brushes. To complete the equation one must, of course, add another quantity, the artist, for, after all, the art is in the artist.

And the importance of the artist — in the American art movement that has stirred the Old World and the New to a degree unmatched in history — must be seen in an entirely new way. It was once true, for instance, that the artist viewed a landscape and then presented to us, on his canvas, how he saw the trees, the sky, and the sun, and we were moved (or not moved) by his vision and interpretation. Today, the finished canvas no longer represents the vision of the artist, rather it *is* the artist. The painting has become a scene in which the artist, in his struggle to create, is seen.

The artist, in this special sense, has become an actor and his tableau is his painting. On (or, indeed, it could almost be said *in*) the canvas a battle is fought, an enemy vanquished.

How battles are fought and sometimes won in the struggle of painter versus canvas varies as much as the painters themselves. Techniques are highly personal. Even the brushes employed range from the most delicate sable-tips to big house-painters' brushes. Almost as commonly used as brushes are palette knives that push the paint in the same way as a table knife spreads a pat of butter evenly up to the end of a stroke, where the butter forms a small lump. Some attack the canvas directly with tubes of ready-mixed color. Others use gallon cans to mix a desired color, then artfully allow accidents to occur as the can is tipped over a canvas spread out on the floor. Special luminous effects can result from sprinkling metallic powder into the paint. By mixing sand with paint the

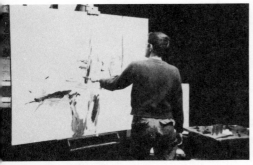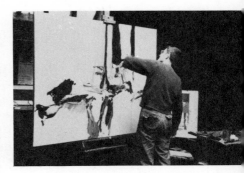

Basic outlines are quickly sketched, and weights and movements are established.

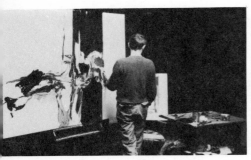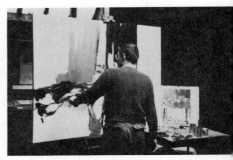

Some areas are refined and the textured surfaces are built up.

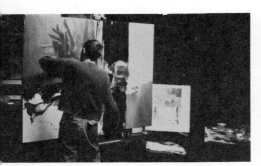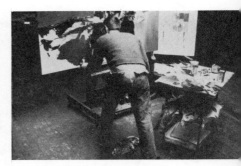

Large, simplified color areas are added to the composition.

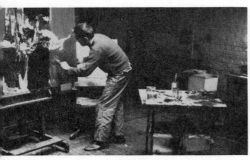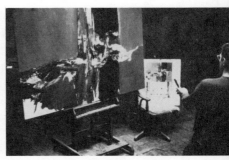

Additional changes in composition are made, thus ending first day's work.

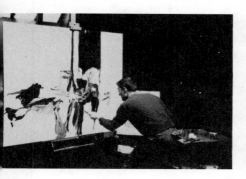

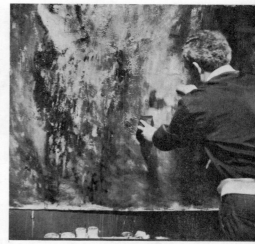

William Gambini shifts the position of the wet paint by using a turpentine-saturated rag.

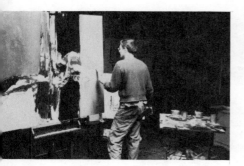

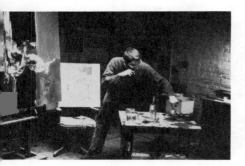

In the series of photos on opposite page, and at left, Budd Hopkins, working from a sketch, paints a picture with brushes and palette knife.

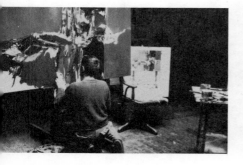

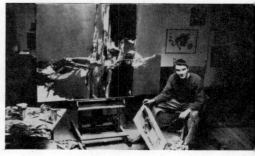

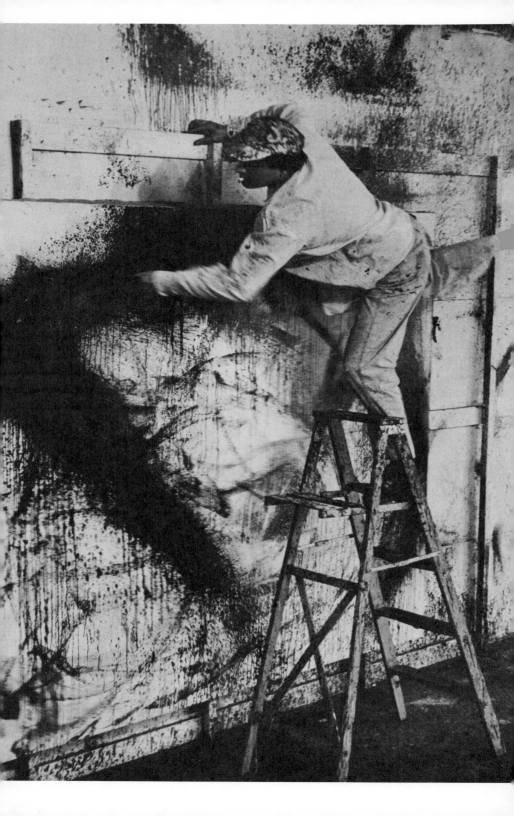

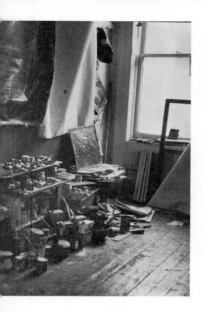

On opposite page, Norman Bluhm demonstrates his manner of splashing strokes which results in accidental drip painting.

Above, when day's painting is finished, empty tubes, soiled rags, containers, and brushes are scattered about (Gambini)/ At right, painting wall and floor beneath are caked with excess paint (J. Mathews)/ Below, Gwytha Pring struggles to place finished painting back on easel.

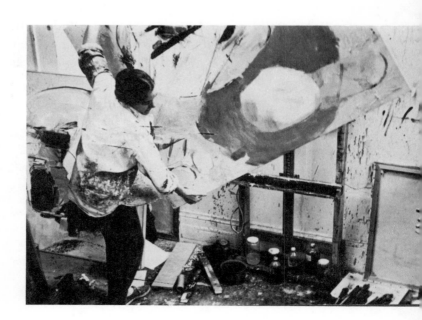

artist can change the texture of his paint to a rough, grainy finish. The tools for any painting may vary to include rollers, spray guns, pieces of wood, rags, a hand, even a foot — anything at all that will provide the artist with a means to fulfill his objective.

This latitude in materials has disencumbered the painter from the traditional kidney-shaped palette that could be comfortably held on his arm. His "palette" may well be a long row of cans lined against the wall, or, perhaps, an entire glass table top covered with a glorious mass of color almost as compelling as the paintings themselves.

In the act of putting paint to canvas the painter assumes his role of an antagonist in a duel with the canvas. He stands back from it and scrutinizes first. Abruptly he goes to the line of cans with a brush, and thrusts it into one of them. Half-running toward the canvas he smacks a streak of paint on it from one end to the other. The paint splatters on his face, on his denims. He watches with satisfaction the unforeseen tricks the paint plays as dripping color invades a white area. A half hour may pass before he moves again. Having scored one point in his struggle, he plans another line of attack as he paces back and forth, hardly glancing at the canvas.

A less violent and more studied approach is made by painters who first sketch the problems to be solved. Working from a charcoal rough or even a completely painted-in miniature of the final work, they can lay the groundwork for a six-foot canvas in an afternoon, and complete the painting in a few days — or a year.

No matter how the painter approaches his canvas, it is always with a sense of excitement, anticipation, and perhaps even apprehension; for he has committed himself to the never-ending struggle to release from himself and realize in the canvas a part of his own being.

4 The Big Struggle

Jackson Pollock

JANUARY 28, 1912 — AUGUST 11, 1956

Page 37: Jackson Pollock's grave marker at East Hampton, L.I.; he died in auto accident, August, 1956, when only forty-four. His paintings now sell for as much as $100,000.

Pickets demonstrating at Museum of Modern Art to protest its policy of "encouraging artists to execute absurdities for the entertainment of its elite public. . . ." Pickets urged Museum to show realistic art. The American Abstract Artists staged a similar demonstration in April, 1940.

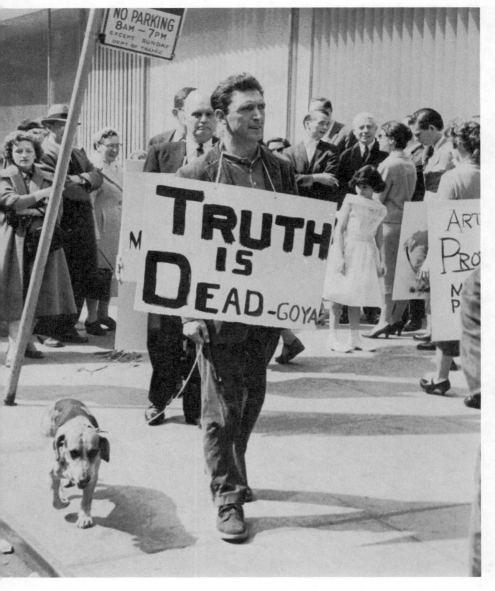

4. THE BIG STRUGGLE

To devote a life to medicine or law is not easy. Long years of expensive schooling precede an underpaid apprenticeship. In practice competition is hard. But the rewards are there for the bright, the skilled, the able.

For an artist, the years of preparation are equally long and in many cases much more arduous. A would-be doctor goes off to college with his community's and his family's blessings and as much of his tuition as it can raise. Spawning a would-be artist is scarcely every parent's dream, and a young artist must be prepared to defend his vocation from the sharpest critics an adolescent can face, his parents. College, art school, and an M.A. become advantages hard-won against a family that at least regards their child as unworldly and at most unbalanced.

Having completed formal schooling, most young men can look forward to settling down to a secure job and a good marriage. An artist may never settle down, let alone permit himself to think of marrying just on the sketchy income that most artists realize from their work. Almost no one buys the work of an unknown painter. So in order to eat, sleep, and keep clothes on his back, a young artist is almost always forced to get a steady job of some sort.

A maverick first to his family, now he has to work twice as hard merely to remain alive in the world outside, a world in which his aspirations are almost always subject to harsh criticism and ridicule.

Keeping body and soul together is a daily victory; supporting a wife and children presents obstacles he may find insurmountable. Painters' wives are a breed apart: how many women are there willing to marry knowing that in all likelihood they will have to provide the daily bread? To a young girl, marrying an

artist may represent romance and high adventure, but the illusions are soon dispelled by the often grim realities of daily living.

Parents first, next society, then sustaining his own family — all must be contended with. And, with all this, the most significant problem of the artist is still the struggle to create. His relation to his art is always new, always changing. He is not interested in what he already knows and can do. His creative duty to himself is that of constant self-renewal.

To achieve recognition as an artist he enters a new arena. The entrenched hierarchy is questioned. If it is found wanting, he may choose to fight "the academy" by striking out on new paths for himself, or he may choose the equally difficult role of assimilating himself to the way pioneered by others.

Rewards beckon the artist, too, but they seldom come during his lifetime. Only posterity can bestow them.

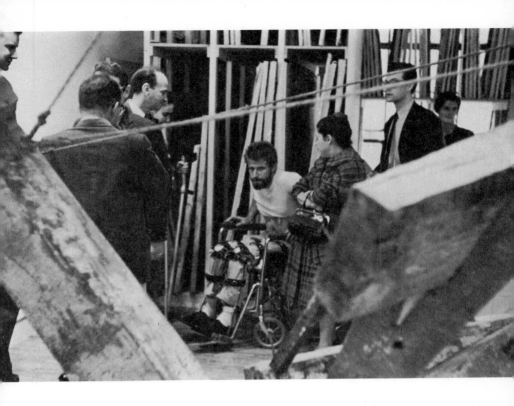

Sculptor Mark di Suvero, severely injured in an elevator-shaft accident, greets guests at his opening at the Green Gallery. Working from diagrams, friends assembled show under his supervision. In the foreground of picture can be seen a section of one of his mammoth compositions constructed of great beams of wood. Another example is illustrated below.

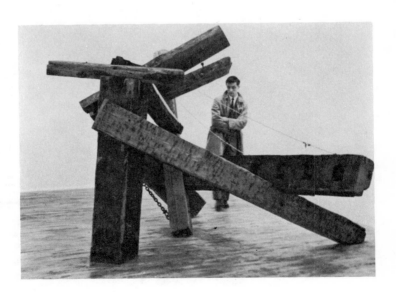

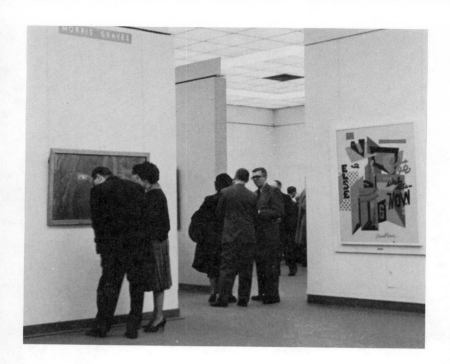

Above, William Sebring directing visitors at Whitney Museum of American Art. He has switched to night watchman's job to have more free daytime for painting/ Right, John Krushenick builds frames in Brata Gallery and frame shop/ Brother Nicholas Krushenick makes living by hauling furniture, paintings, and sculpture, also shows work at Brata.

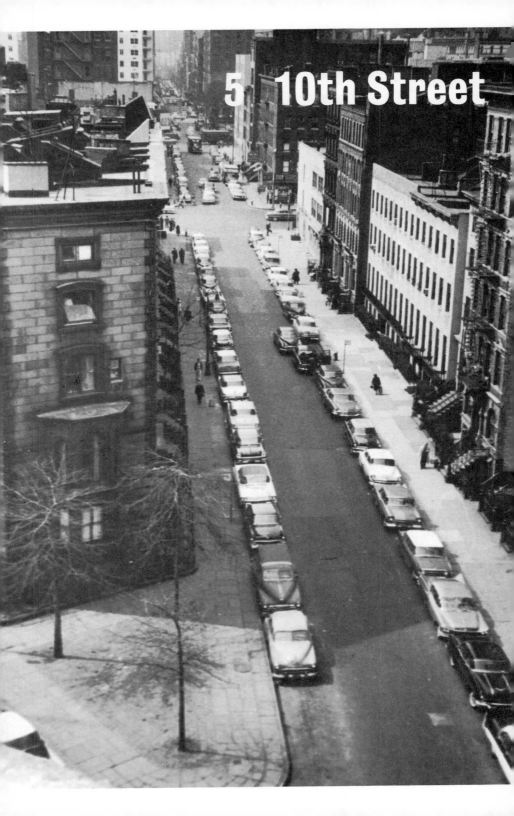

5 10th Street

Page 43: View of East 10th Street from Stuyvesant Street facing west.

Exterior and interior of Friday-night· opening at Tanager Gallery. In the foreground, Alex Katz is at left, Jim Brody, center, and sculptor Ibram Lassaw at right.

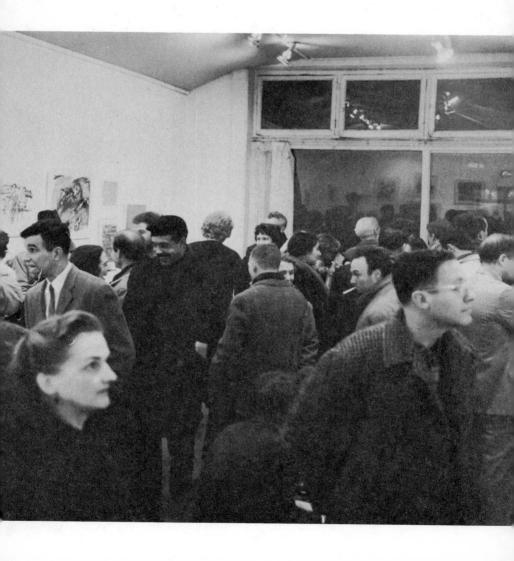

5. 10th STREET

To produce a violent reaction, a chemist carefully measures the ingredients of his formula, then stands back to "let 'er rip." Without the aid of a scientist or any calculation of elements, a group of artists and sculptors meeting in the early '50's concocted a potion so explosive that walls are still being shattered.

The cloud of actions and reactions around the force conveniently labeled 10th Street makes it difficult to chart just what happened and when. A chain of circumstances, more or less related at the time they occurred, seems today, with the vision granted by hindsight, to have set loose the force.

Without doubt, the vitality generated by the young abstract artists of the late '40's represents the awakening. Their difficulty in finding established galleries venturous enough to show their work was another important element. Unable to find an audience alone, the artists banded together and attempted to run cooperative galleries, but the costs were high, and somehow none succeeded. At about the same time a few of the leaders in the abstract movement happened to find studios on East 10th Street. The street was a dreary, undistinguished extension of Skid Row in an area of the Village condemned for redevelopment. The rents were low, space was good, and soon younger disciples were clustering in studios along the street.

To the young members of a struggling cooperative gallery on West 4th Street, it must have seemed logical to move their gallery to the friendly atmosphere in East 10th Street. Following the opening there of the Tanager Gallery and the Hansa Gallery nearby, events moved rapidly. Interest from artists, uptown dealers, and the public was fanned by the rapid succession of galleries opened on the street. After every available store was let, galleries began to open around the corner on 3rd Avenue. Enlivened by the

public's interest and the obvious success of the 10th-Street experiment, the spirit began to invade other areas of the city.

Although a few of the newer galleries are privately owned, the majority are faithful to the original Jane Street Gallery concept. The galleries are owned cooperatively by about seven to fifteen artists, with each contributing member paying his share of the rent and upkeep. Shows rotate among the members and invited guests; at Christmastime, the galleries, with a communal spirit rarely found uptown, have their annual invitation exhibitions, in which works from all the members and a selected group of friends are hopefully displayed to a public on its annual shopping spree.

No matter what the season a carnival atmosphere prevails on 10th Street. The galleries and newly opened coffeehouses have not driven away the dingy basement poolrooms, the cheap gin mills, the dirty restaurants, or the huge hotel employment agency that offers a last chance to Bowery derelicts. On weekday afternoons it is always busy. The poolrooms are open, but so are the galleries for artists who stop in to view the shows, to compare, and to criticize.

On Friday nights, when openings are held, crowds jam the block, aglow from lights in all the gallery windows. The party atmosphere comes as much from the artistic excitement as from the young couples on an evening out in the Village, enjoying the informal hospitality of the galleries.

Tenth Street has been and is, for the artist, a rallying point whose standard has rocked the international art world.

View of 10th Street looking east from Fourth Avenue/ Right, building at Fourth Avenue formerly occupied by The Club/ Below, Sam Goodman hauls paintings back to studio after exhibit at Camino Gallery.

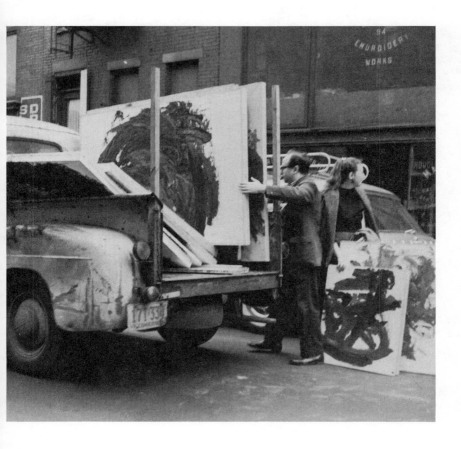

Center, Robert Wiegand shows paintings at Phoenix Gallery on Third Avenue/ Below, Sal Sirugo at his exhibition at the Camino/ Bottom, Emily Mason in the Area Gallery. Her mother, Alice Mason, is a painter as is also her husband, Wolf Kahn.

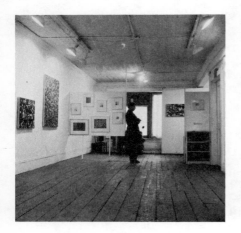

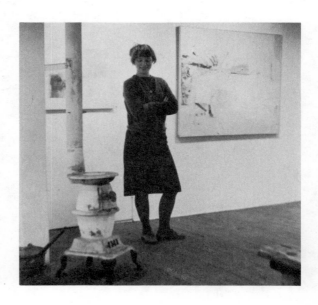

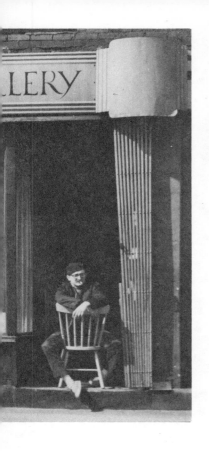

The Nonogan, formerly a plush restaurant at Second Avenue and 6th Street, is considered one of the 10th-Street galleries/ Below, March Gallery, like others, has constant problem with its neighbors.

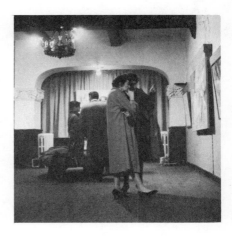

Artists traverse 10th Street chatting with friends. Willem de Kooning is on Employment Agency stoop with novelist Noel Clad. Through Tanager window (left) sculptor Gabriel Kohn is talking with gallery director Sally Hazelet.

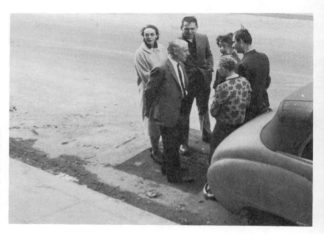

De Kooning moves to street and is joined (l to r) by Jo Ellen Rapeé, sculptor David Slivka, **Craft Horizon's** editor Rose Slivka, art reviewer Irving Sandler, and Lucy Freeman (Sandler), who was sitting in Tanager, above.

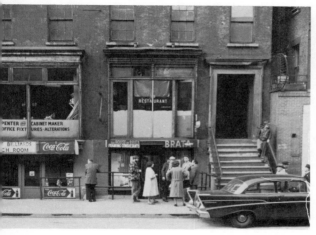

Kohn and Clad cross street and continue conversations with (r to l) George Goya-Lukich, his wife, Bernice D'Vorzon, and Knute Styles. All have shown in 10th-Street galleries.

6 See You Around

6. SEE YOU AROUND

When an artist sets aside his work, his primary diversion is his own family. In blatant defiance of the laws of economics and the popular illusion of an artist as a "free soul," most artists do marry and have children. Like all children, theirs want to be played with and taken on family outings. Looking in on the 10th-Street galleries is always a favorite trip on Saturday or Sunday afternoons. While their parents chat with friends about the exhibition, the children turn the gallery into a playground as screams of peek-a-boo sound from behind a piece of sculpture. But even the children don't ignore the art, and fresh and enchanting insights about a painting may put proud or embarrassed smiles on a father's face.

Artists also share in the American passion for cars, and a Greenwich Village car rally almost always includes members of the art community. At Saturday-night parties many of the artists show that they are also accomplished musicians.

Most evenings, weekdays or weekends, a painter seeking the company of painters goes to a bar or diner. "The bar," which for the artists needs no further identification, has little in common with the usual run of Village taverns, either those that sport overblown photos of unattractively seedy dancers to lure tourists inside, or those at the other extreme, oppressively wood-paneled to evoke Old English inns, complete with ceilings on which dust has been sprayed to convey the illusion of antiquity so dear to the postcollegiate pseudo intellectual.

The Cedar Street Tavern (or "the bar") wears no false face. Workingmen of the neighborhood are as comfortable in the plain, well-lit room in the afternoons as are the artists at night. For the artists, who first "discovered" the bar, it has many attractions. The bulletin board in the back lists all sorts of domestic and

community notices — jobs wanted, lofts wanted or to let, even gallery announcements are posted. The owners and bartenders are generous in cashing checks, extending credit, and being helpful in a variety of ways to the artists, who, in turn, seem to have started a bonanza for the tavern. Once the exclusive premises of the art world, the Cedar Street regulars' ranks have swelled to accommodate an astonishing variety of singers, dancers, actors, poets, miscellaneous celebrities and characters, and the inevitable sightseers who come to view the animals in their zoo.

After the bars close, conversation continues either in Riker's or The Chuck Wagon, late night restaurants conveniently close to the Cedar. There, the night's debates are sleepily concluded, and in the early morning light the artists go home.

Page 51: Stanley (Spike) Landsman, sports car enthusiast, is first car off in Greenwich Village Sports Car Club rally. Rally leader and **Village Voice** auto editor, Daniel List, waves starting flag.

Left, Landsman wins with a smile. His work has been exhibited at the Allan Stone Gallery.

Phyliss Yampolsky with new baby, Gia. Child goes with mother to galleries and to parents' studios. Yampolsky is married to painter Peter Forakis.

Shane Brodie tweaks father's nose. Gandie Brodie studied with Hofmann, shows image painting at Durlacher on 57th Street.

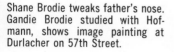

Paul Georges spends quiet day at
home with wife Lisette, baby Yvette
and oldest daughter, Paulette. His
wife is the model for many of his
paintings.

Bopping around town—Seymour
Boardman, Angelo Ippolito, Alfred
Jensen.

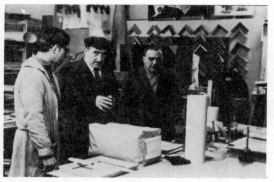

Besides being the framers for most New York painters and museums, the Brata Gallery is also reported source of all local gossip. John Krushenick, left, with sculptors Phillip Pavia and Raoul Hague.

Above, out for relaxation from hard day of painting are (l to r) Bill Gambini, Boris Lurie, and Sam Goodman/ Right, Al Held, Peter Stander and Max Spoerri, jangling the pay phone for lost coins. Stander and Spoerri, both married, do plumbing and carpentering to support their families.

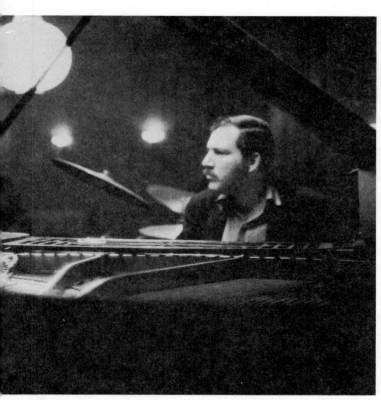

Sitting in at private party in the East Side Jazz Gallery, Larry Rivers blows sax while Howard Kanovitz beats out piano tune. Rivers was once a TV quiz champ.

Dillon's Bar on University Place provides setting for shuffle board games with target painter Jasper Johns pitching. Other participants (l to r) are Bill Giles, Anna Moreska, Robert Rauschenberg, dancer Merce Cunningham, and composer John Cage.

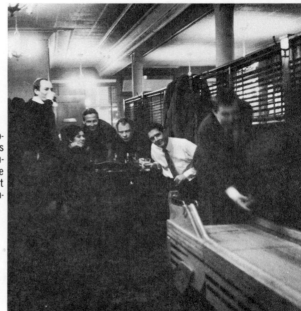

Cedar Street Tavern owner, John Bodnar, gets bar straightened out before the rush. Photo was taken at 8 a.m., only time premises are empty/ Below, painters Held, Joe Stefanelli, Mike Kanemitsu, and sculptor Tom Doyle confer as to whether or not they will buck huge crowd inside.

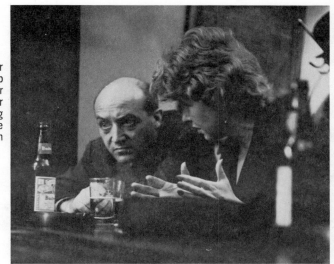

Sitting at the bar, sculptor Isamu Noguchi (right) is deep in conversation, while in rear aisle, Mark Rothko and sculptor Peter Grippe converse standing up. Rothko had a retrospective exhibit recently at the Museum of Modern Art.

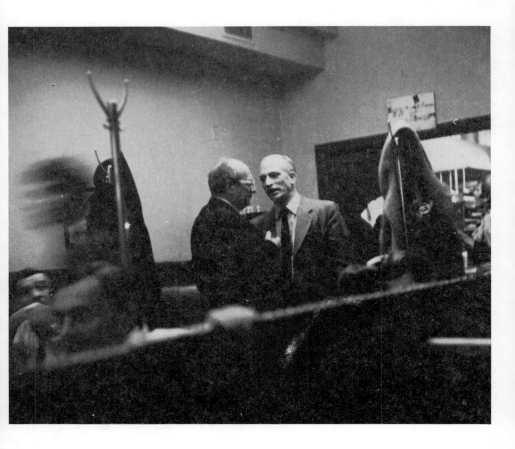

Sculptor George Spaventa (above, facing) and friends stop at Riker's, a popular coffee hangout after the bars close/ Right, the Chuck Wagon, diagonally across from Riker's, is more spacious, and even more popular. At the table (l to r) Leonard Horowitz, Francis di Cocco, dancer Merle Marsicano, Nicholas Marsicano, who won a Hallmark painting award, architect Peter Goodwin, Joan and Gene Vass.

7 Where's the Party?

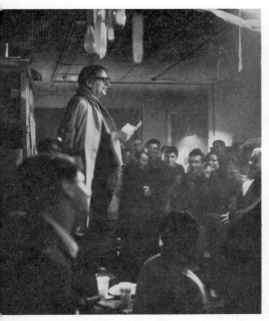

Page 61: Bob Taeger is seen through the haze of smoke at Bob Smithson's party.

Left, Aristodimos Kaldis reads a dedication at wedding party for Fleur and Stanley Landsman.

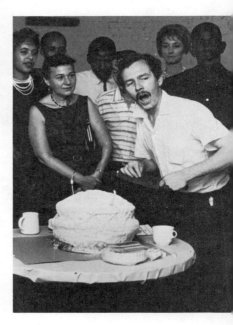

Right, Maurice Bugeaud slices up his birthday cake/ Below, a bon voyage celebration at Grace Borgenicht's with Conrad Marca-Relli left, and Willem de Kooning at right with teacup.

7. WHERE'S THE PARTY?

A loft party is a Saturday-night ritual. There is no such thing as a restricted list of invited guests, for all are welcome. Welcome, that is, if there is room. These loft parties can mushroom by word of mouth from just a few invitations to a group of staggering size, upwards of four hundred people, including artists, writers, poets, critics, and the local barflys. One artist, experimenting in the theory of party-giving, told only three "Elsa Maxwells" of the art world about his party. By his actual count 227 guests showed up.

The psychology of the art world determines exactly which artists may be expected at which parties. An artist whose star is rising hopes to boost his reputation by being seen speaking familiarly with a famous host. Since every artist worth his canvas either feels his star has been or should be rising, a well-known figure in the art world can reasonably expect a thundering herd to appear at the mere rumor that he's giving a party. A less successful artist may have difficulty in attracting as ambitious a group, but he can still count on his friends, their friends, and anyone else who may have overheard an invitation or his address.

Having provided the impetus and his loft, little more is expected of the host. Most of the guests bring their own bottles, which will frequently disappear. The host will often have a keg or two of beer set up, and he may provide a few bottles of liquor, some cheese, and perhaps some salami or liverwurst if the occasion and his pocket warrant the expenditure.

Early comers to the party are sober and quiet. The arrival of musicians helps relax the tension as voices are raised in competition with the instruments. If there is no live music, the canned variety is tuned very loud, and the thump of dancing can be heard six flights down. When the dancing is accompanied by bongo drums the party can reach a state of real frenzy. As the

noise reaches a crescendo conversation becomes impossible. All the food and liquor have long since been gobbled up, and still-thirsty guests dash out to buy more beer. The heat is stifling; so windows are opened to bring in fresh night air. Passers-by attracted by the noise and lights stop in, unheeded, either to stay or go as their fancy dictates.

Throughout the evening the party is constantly in flux as restless crowds come and go. More and more gradually leave. Then the littered floor with its stamped-out butts, spilled drinks, and smashed paper cups gradually becomes visible. A dim haze hangs over the lights. By now the loft, nearly empty, can be seen with all its furnishings pushed back, doubled up, stored away — ready for a staggering cleaning job. Inevitably, there is that last, bewildered guest with a cheap raincoat over his arm, looking hopelessly for his new Burberry.

It was a *good* party!

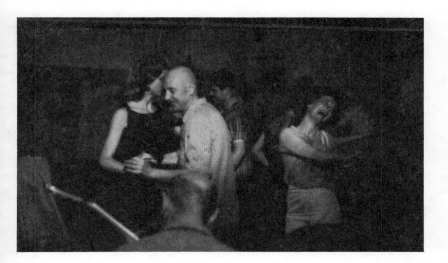

New Year's parties at The Club. Len Lye dancing above center. Artist Lye also produces experimental films/ Right, refreshing pause with Nancy Martin, critic Harold Rosenberg, magazine editor Pete Martin, Franz Kline, poet Ted Joans and James Cuchiara/ Bottom, sculptor William King dances rock 'n' roll number.

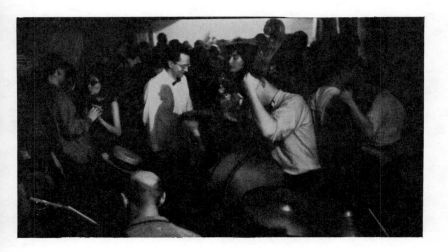

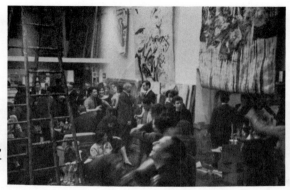

Left, when the floor shakes, so does the camera. Al Leslie and Dody Müller do the Charleston.

An ideal setting, with lots of space, and paintings and ladders for atmosphere.

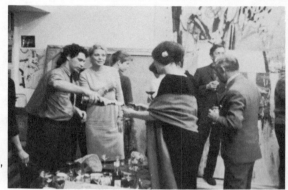

Plenty of good champagne for all, and Al Leslie is pouring.

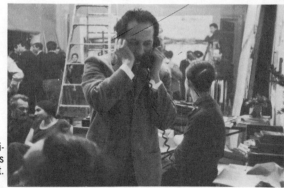

Norman Bluhm trying the impossible above the din, with Paul Jenkins and poet Margaret Randall at left.

The clean-up — paper cups, old cartons, decorations. Writer Patsy Southgate in center.

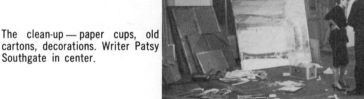

At the end of the party, a good-night kiss

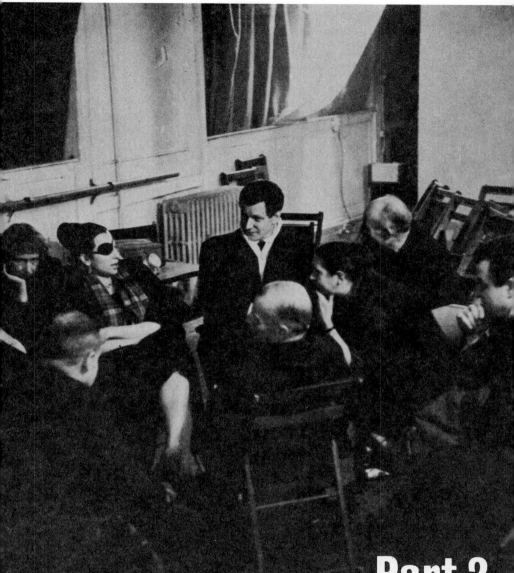

Part 2
Achieving Status

8 The Club

Page 69: A discussion after Club meeting engages (l to r) Leonard Horowitz, Ann Winter (with patch), architects Mathias Goeritz and Frederick Kiesler, his secretary, Lillian O'Linsey, and sculptor Kenneth Campbell.

Panel discussion when The Club was at Fourth Avenue and 10th Street. Topic was "What Is the New Academy?" with speakers (l to r), critic and painter Hubert Crehan, **Art News** editor, Thomas B. Hess, critic Harry Holtzman, and painter Herman Cherry. Rice-paper poster from San Francisco was Chistmas gift to The Club.

8. THE CLUB

Several years ago one of the principle rendezvous of the art community was the Waldorf Cafeteria on 6th Avenue and 8th Street. Nighttime roundtable discussions there drew together a post-World-War-II band of artists who were in the process of discarding traditional European and American concepts of art and seeking a more personal idiom.

The beginnings of a real club started in 1948 with the formation of the "Subjects of the Artists," an informal school operated by a half-dozen artists who gave instruction on a rotating basis to a handful of students in an 8th-Street loft. To establish a community center atmosphere, the school started Friday-night panel discussions given by artists for the benefit of its students and other interested persons. The subjects discussed included painting, sculpture, philosophy, music, and anthropology.

The nature of the events perhaps excluded some artists from participating, for it was shortly thereafter that another group of artists opened a social club, by coincidence, just a few doors away from the school on 8th Street, and it functioned simultaneously with its neighbor. It was this group which in 1948 formed the nucleus of The Club. "Subjects of the Artists," lacking continuous financial support, had by that time been taken over by New York University, and finally dissolved.

The purely social function of The Club eventually developed to include the panel discussions which involved the internal struggle of art and its social situation. The Friday-night programs expanded to incorporate other interests, and poetry readings, films, and concerts were presented.

The history of The Club since its first years on 8th Street is marked by a restless series of moves, all within the area of a few blocks. From 8th Street The Club moved to Broadway, from

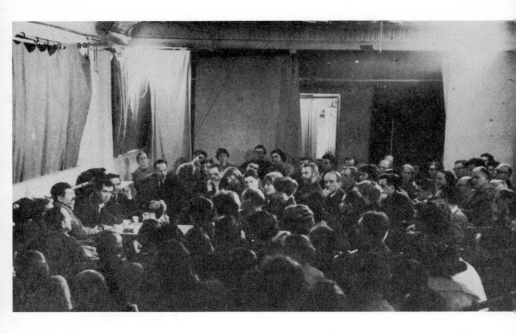

Above, panel at Second Avenue and 10th Street discussing "Non-critic-artists," with members at table Joop Sanders, Herman Cherry, Louis Finkelstein, and sculptor Robert Mallary/ Below, at Saint Mark's Place; some of those seen standing are (l to r) Sasson Soffer, Lester Elliot, George Dworzan, William Littlefield at door, Mark Baum, Arthur Elias.

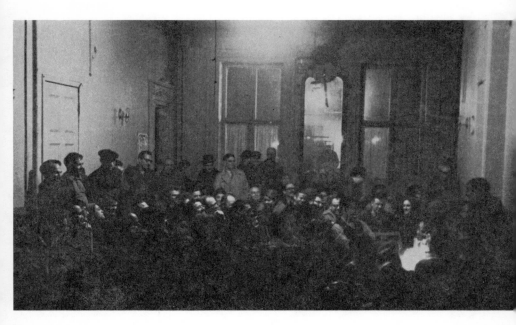

Left above, sculptor Campbell in Halloween costume/ At right, painters Jenkins and Goodman and literary agent Guenther Stuhlmann/ Below, a Club poetry-reading by poets at table (l to r) Gilbert Sorrentino, Diane di Prima, Max Finstein, LeRoi Jones, Joel Oppenheimer.

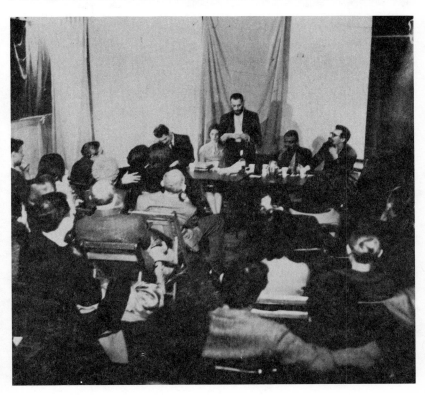

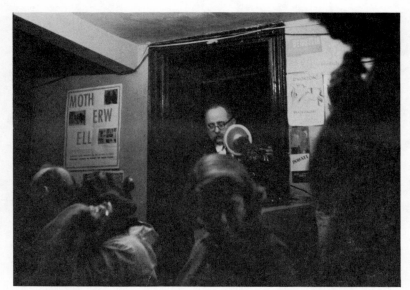

Films being presented by Ilya Bolotowsky, showing "Artists in Studios and Subways."

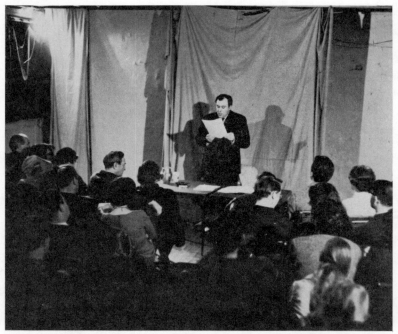

England's distinguished art critic, David Sylvester, discussing Giacometti.

74

Milton Resnick (facing) in animated conversation with
Irving Kriesberg.

Attentive audience: (l to r) Ad Reinhardt,
Lucian Krukowski, Philip Pearlstein, and
Tania.

The Club doorman setting up chairs.

Coffee and cookies: in the mad rush, Krukowski, Sam
Schapiro (near urn), Gabriel Laderman, Roy Newell
center, Neal Mallow and Littlefield behind counter.

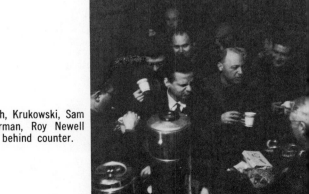

Broadway to East 14th Street, then to 10th Street, next to 2nd Avenue, to St. Mark's Place, and finally to Mercer Street, just a few doors from its original home.

The physical changes in its setting parallel the growing refinement in the character of the discussions. Discussions today rarely carry the fire of personal involvement that they once did. Although most of the founding members' names still appear on The Club list — a carefully guarded *Who's Who* of the art world — they come to the meetings much less frequently.

The Club does not stand still, however, for new members are added each year on a basis that seems to be compounded equally of sociability and sincerity of purpose. While a major proportion of the new members comes from the community of artists, The Club welcomes those in allied fields with a sympathetic interest in the advance guard of all the arts.

Meetings are still held weekly and the programs in any year encompass an impressive number of subjects. Nonmembers active in the theater, poets, and critics from abroad are invited to lecture; film nights are presented annually. But for the artist the chief interest and value of The Club are in the panel discussions conducted by five or six members who explore such amorphous topics as "What We Don't Have to Do Anymore," "Patriotism in the American Home," "What's Wrong with Wrong," "Who Owns Space?" or "What Is the New Academy?"

The stature of The Club in the art world is difficult to ascertain. Once a simple forum for new ideas, it seems to have evolved into a symbol of a rebellion that is well on its way to victory. But with succeeding generations rebellions are fought anew. Whether The Club will remain a standard of the rebellion of the '40's, or if its new members will be able to revitalize it into a standard of the '60's, remains to be seen.

9 Going Uptown

32
east
69

JACKSON GALLERY

MARTHA JACKSON GALLERY

NEW FORMS NEW MEDIA
VERSION II

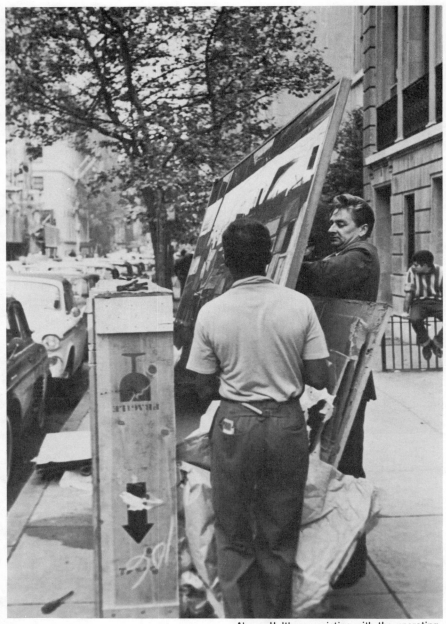

Above, Hultberg assisting with the uncrating.

Page 77: Paintings **by** John Hultberg arrive at the Martha Jackson Gallery after out-of-town exhibition.

9. GOING UPTOWN

Many art galleries find themselves in the unbusinesslike business of selling a product whose supply far exceeds the demand. Gauging the market correctly, and at the same time fulfilling the self-imposed obligation to serve as a showplace for new talent requires a conscientious gallery director to have the acumen of a stockbroker and the credit of a millionaire.

Galleries that specialize in the work of "masters," old and new, are not faced with quite such a dilemma. Their chief problem is the relatively simple one of meeting the demand for fine examples of painting and sculpture by well-established names. But the galleries that do take up the challenge of presenting the work of new artists are literally besieged by unknowns, each convinced of his worth, and all vying in the heartbreaking competition for recognition.

These artists are competing in a game whose ground rules change constantly. At one time an artist's search for a prospective gallery was a fairly uncomplicated process. After much hemming and hawing, the artist would select a few pieces he felt were representative of his best work, and then get them uptown somehow. Making the rounds was not difficult, either, since a few years ago there were only three or four galleries that would even look at new work.

Now, however, the number of galleries that might conceivably be interested in new talent has more than quadrupled, and since most artists today work on a large scale, they don't make gallery rounds with actual samples. It is more likely that they will have a photographer who specializes in painting or sculpture take color photos of the best pieces, and then they will make the rounds with slides in hand. The weakness of this approach is the wear and tear on the galleries, constrained to interview in a short space of time

any number of artists whose work they may or may not care for, and on the artists, put in the somewhat humiliating role of being door-to-door salesmen.

Less taxing on both parties is the more oblique approach where the initiative, on the surface, comes from the dealer. This will result, perhaps, from an exhibition on 10th Street that a dealer may have seen, or from the recommendation of an artist whose work is already handled by the gallery. Whatever the happy circumstances, the gallery's director, having seen or heard about an artist's work, will visit his studio. Countless stairs are climbed yearly by dealers who take seriously their responsibility to see as much as they can. Their quest never ceases, for every year there seem to be more young artists clamoring for attention. So talent, favored by chance, may be brought to light early in an artist's career; sometimes the breaks only come tragically late in life.

Once he has been selected by a gallery, an artist can for the first time know the security of support. Some galleries play the role of Maecenas and arrange to buy the paintings or sculpture outright. More frequently the galleries will take the work on consignment and keep a large commission from the purchase price. If a gallery's faith in a particular artist is unusually strong, it may even contract to pay the artist a yearly stipend, thus enabling him to live and work on a steady income. This is the general custom in Europe, but it is a method of operating that is rarely practiced in New York.

In preparation for a show at Howard Wise, Fred Mitchell is on stool, in back of the gallery, restretching canvas.

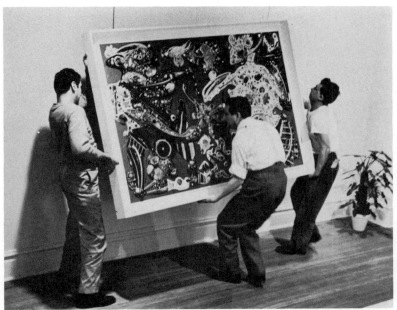

The great bulk of the painting requires Alphonse Ossorio, center, to get assistance from painters Athos Zacharias, left, and Sal Sirugo. Ossorio has been with Betty Parsons Gallery for twenty years.

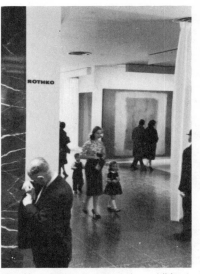

The Mark Rothko retrospective exhibit at the Museum of Modern Art.

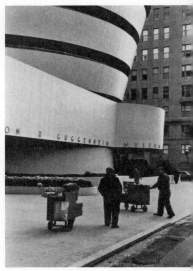

Bagel and chestnut venders at entrance to Solomon R. Guggenheim Museum.

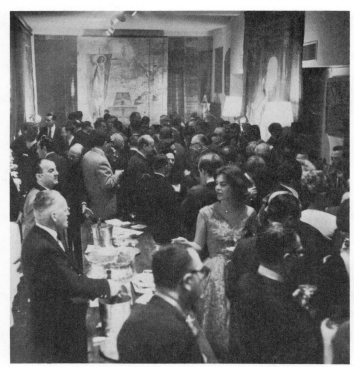

A champagne reception at R. T. French & Company to introduce a painting by Salvador Dali.

ALCOPLEY • BOUCHE • BROOKS • BUSA • BRENSON •
CAVALLON • CARONE • GREENBERG • DE KOONING • DE
NIRO • DZUBAS • DONATI • J. ERNST • E. DE KOONING • FERREN
• FERBER • FINE • FRANKENTHALER • GOODNOUGH • GRIPPE
• GUSTON • HARTIGAN • HOFMANN • JACKSON • KAPPELL •
KERKAM • KLINE • KOTIN • KRASSNER • LESLIE • LIPPOLD •
LIPTON • MARGO • MCNEIL • MARCA-RELLI • J. MITCHELL
• MOTHERWELL • NIVOLA • PORTER • POLLOCK • POUSSETTE
DART • PRICE • RESNICK • RICHENBERG • REINHARDT • ROSATI
• RYAN • SANDERS • SCHNABEL • SEKULA • SHANKER •
SMITH • STAMOS • STEFANELLI • STEPHAN • STEUBING •
STUART • TOMLIN • TWORKOV • VICENTE • KNOOP •

COURTESY THE FOLLOWING GALLERIES: BORGENICHT, EAGAN,
TIBOR DE NAGY, THE NEW, PARSONS, PERIDOT, WILLARD, HUGO

MAY 21ST TO JUNE 10TH, 1951

PREVIEW MONDAY, MAY 21ST, NINE P. M.

60 EAST 9TH ST., NEW YORK 3, N. Y.

9TH ST.

EXHIBITION OF PAINTINGS AND SCULPTURE

10. ANNOUNCEMENTS AND INVITATIONS

Once a satisfactory arrangement has been made between the dealer and the artist, the happy event is usually celebrated by a showing of the artist's work, accompanied by a reception. No list of proposed wedding guests is more lovingly pored over than the list of invitations for an art show. The artist wants to invite all his friends, his relatives, his wife's relatives, his teachers, and possibly his students.

The gallery, predictably, makes up its list of guests with an eye to sales and prestige. Every gallery has a list of collectors whose interest in a new talent might well be aroused by an invitation. In addition, the gallery must be sure to send notices of the new show to the museums, critics, reviewers, and other painters.

It is perfectly understandable that the artist's personal "public" welcomes the invitation as proof that he has at last become one of the elite. One can easily imagine, too, what an avalanche of invitations must smother the officials of the art world between September and May. So the problem of creating an invitation that will at least spark their notice has resulted in a variety of novel solutions. Some announcements are made up in poster size, and can only be mailed in a tube. Others have even been printed on paper bags and on tissue paper. Still others, handsomely and expensively printed in color, reproduce works from the show. This kind of invitation often resembles a museum catalogue. If the reputation of the artist warrants the extra expenditure, his dealer may prepare a limited printing of his illustrated announcements to be signed by the artist and sold by the gallery.

After the friends and relations, collectors, and officials have received their individual invitations, posters are often tacked up along 10th Street to attract the notice of anyone else in the art world who may have been overlooked.

More restrained public notices of forthcoming shows appear in a few selected places. The art pages of the Sunday *New York Times* and *New York Herald Tribune* are the major newspaper outlets. Announcements of openings and shows in progress also appear in *Cue* magazine, *The New Yorker*, and naturally the art magazines.

On 10th Street, the costs of this advance publicity are paid by the individual artists, while uptown it is usually the gallery that foots the bill.

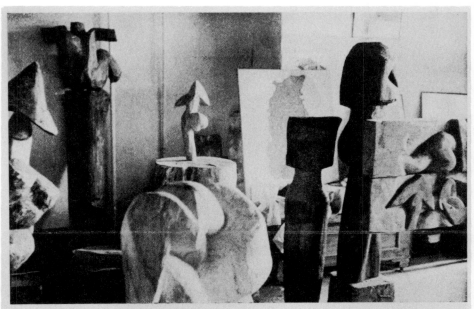

Sculpture and Drawings Opening January 10 (5-7 P.M.) through February 4, 1961
Stephen Radich Gallery 818 Madison Avenue, New York City, N.Y.

Mary Frank

Page 83: Poster announcing a major group exhibition of "New York School" painting and sculpture.

Above, announcements in 10th-Street coffee shop/ Right, sign on window of old Delancey Street museum for Jay Milder exhibition/ Bottom, posters on wall at 10th Street and Fourth Avenue near Briggs Book Shop.

Various announcements (see also pages 85 and 88) of painting and sculpture shows at downtown and uptown galleries; some done by letterpress or offset, some typewritten or hand-screened.

if it is sky that we desire ...
and when do we ever not desire
sky ... something clean and clear
and unendingly unpredictable ... the real
"floating life" ... then this is the
new beauty that HERMAN
CHERRY understands very well
... it hangs awkward and delicate
with the brutality of the clean and
clear with the transparent ambiguity of
immediacy * Lucia Dlugoszewski * the
POINDEXTER GALLERY cordially invites
you to the opening on monday
may 18 1959 at 21 west
56th street from 5 to 7 p. m.

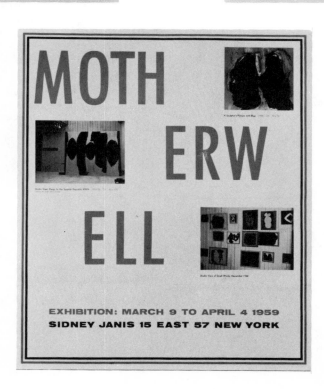

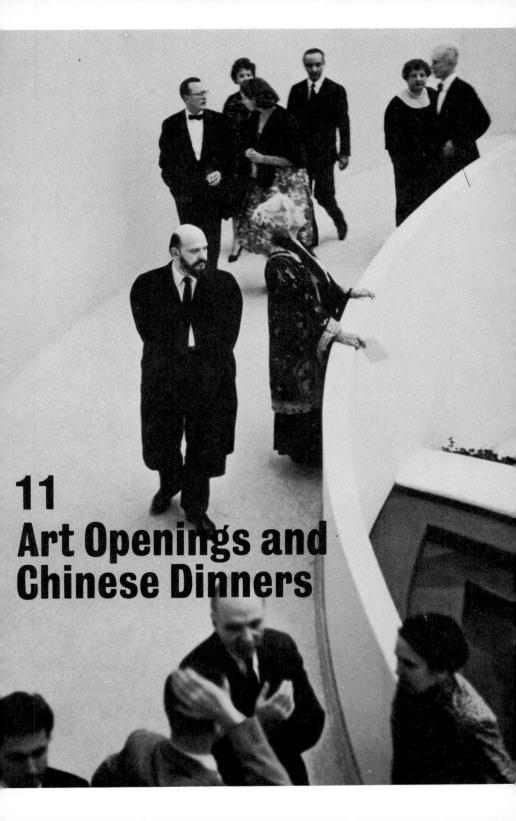

11
Art Openings and
Chinese Dinners

Page 89: Writer Leo Lerman at the inaugural opening of new Guggenheim Museum.

Left, some of the early visitors in the lower gallery/ Below, the Martha Jackson Gallery at the opening of Alfred Leslie's show. Leslie is in dinner jacket. In rear, is reviewer James Schuyler, at right, Grace Hartigan and Bob Thompson. Leslie first exhibited in 1949.

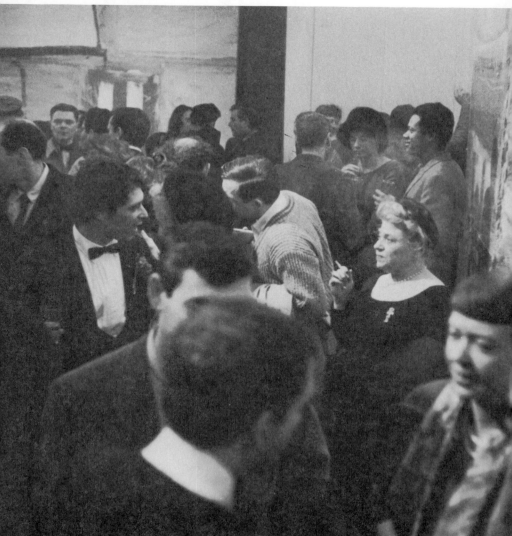

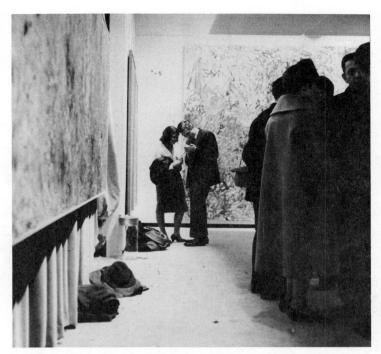

Sven Lukin taking vital information at Milton Resnick's show. Lukin was born in Latvia, and he exhibited recently at Parsons, Section Eleven.

11. ART OPENINGS AND CHINESE DINNERS

A standard cliché in art circles says, "No one comes to an opening to see the show." Unfortunately, this is most often true. It is also worth noting that few collectors come to an opening to buy paintings, and for the same reason: they can't. The crowds that trot from show to show on Monday or Tuesday opening nights uptown completely fill the galleries. Paintings are partially, if not wholly, obscured, and small pieces of sculpture totally disappear in the crowd.

Who makes up this mob? About half the people at an opening can be classified as belonging to the artist's claque. In addition to his wife and children, his following will probably include collectors of his work, close friends, and the other artists represented

Above, the first exhibition at the Howard Wise Gallery, with the artist Milton Resnick in center; at left, writer Bruno Palmer Parona/ Right, Resnick's exhibition at Poindexter Gallery the previous season; the group includes in front: Lester Elliot, Sylvia Stone, Alice Yamin, Landes Lewitin, Pavia, and Green Gallery director Dick Bellamy.

Much shaking of hands, good conversation, and new acquaintances/ Above, Ann and Hub Crehan greeting sculptor Blanche Phillips/ At right, Kaldis, de Kooning, and Hess.

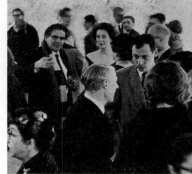

Friedl Dzubas and Landes Lewitin at a Museum of Modern Art Opening.

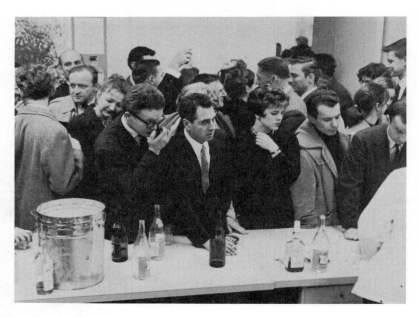

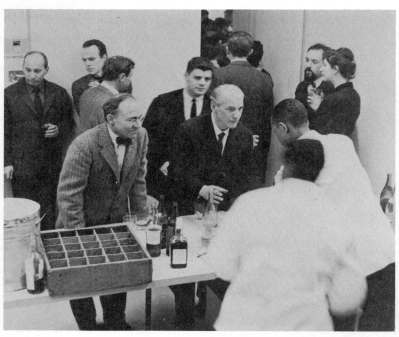

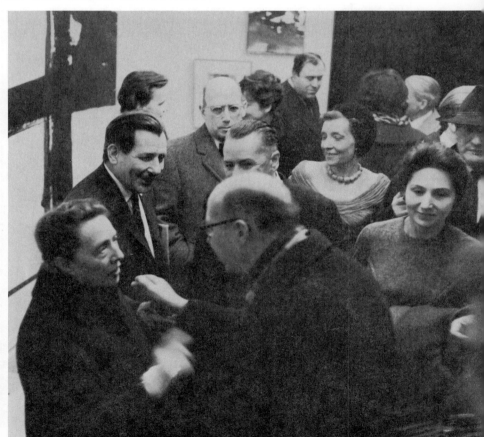

Left above, at Wise Gallery, free-flowing drinks, and John Grillo at the center of the table/ Left below, at nearly dry well, (l to r) Joseph Stefanelli, John Curoi, Bart Perry, sculptor Ernest Marciano, Bill de Kooning and Harold Cohen (with beard)/ Right, John Reed with baby. His book, **Hudson River Valley**, was recently published/ Below, Franz Kline at his opening at the Janis Gallery, (l to r) Harriet Janis, Ethel and William Baziotes, behind them, museum director Robert Goldwater, his wife, Louise Bourgeois, and Mark Rothko.

95

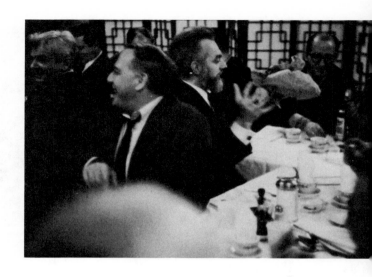

Top, horseshoe-style Chinese dining, (l to r) Giorgio Cavallon, Philip Guston, Paul Jenkins (exploding paper bag), and Emanuel Navaretta/ Below, single-table family style, host David Lund at left center, Sol Bloom and George Morrison at end of table, Marty Bloom at right center and Emily Mason, right foreground.

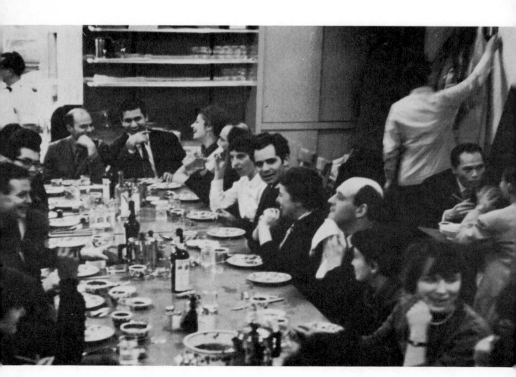

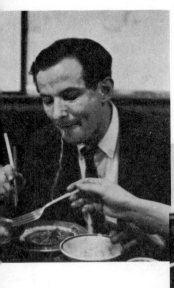
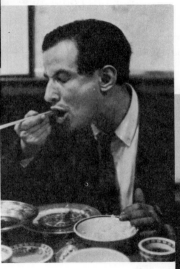
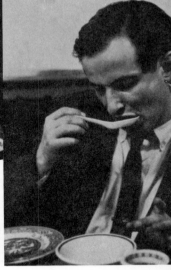

Leonard Horowitz demonstrates the art of eating a Chinese
dinner. He paints abstractions, but at one time was a realist
artist.

by the gallery, who customarily, through courtesy, appear at all their gallery's openings. An artist whose opening is ignored by such a band of devotees has good reason to feel that he is on the skids.

But this really is not a likely prospect. The artist at his opening is almost always surrounded by a crowd of warmly enthusiastic friends, and he appears "fresh as paint" in a new suit and haircut. The rather bemused look in his eye is, perhaps, partly explained by his noting the gallery director's nervous circling of the room shooing people away from paintings that are not yet quite dry. Many a gallery first-nighter has come away from an opening with a paint-smudged coatsleeve. The artist is also apt to be suffering from a familiar "opening night" fear that his canvases have been carelessly hung that morning and are about to fall from the walls.

In addition to family, friends, and fellow artists, the openings also attract an assortment of young men and women who are more familiar to the bartenders than to the artists. Drinks in hand, the crowd circulates, enjoying the good company and conversation that lasts unabated to closing time, when, by ringing bells and flashing lights, the gallery is emptied of the general public.

Remaining friends wait for the hero of the evening whose stock rises even higher when he takes them all out to dinner. For reasons now unknown this "opening night" dinner is invariably eaten in a Chinese restaurant. Replete with excitement and egg rolls the artist basks in his glory.

12 The Critics and the Magazines

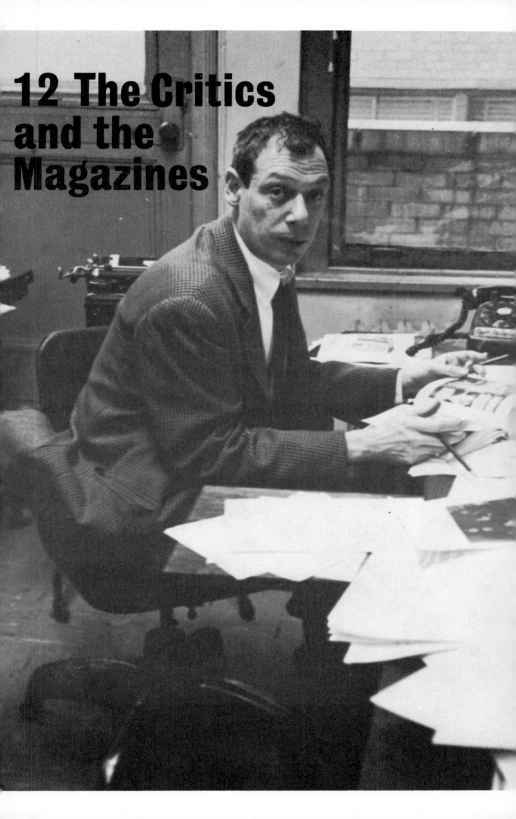

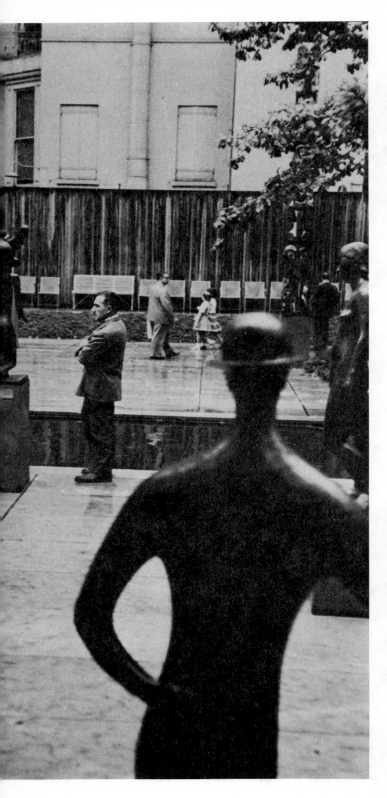

Page 99: Thomas B. Hess, Executive Editor of **Art News**, in his office. He joined the magazine right after the war, during which he was a fighter pilot. His book, **Abstract Painting** (1951), was first to treat new American painting seriously and at length.

Phillip Pavia in the garden of the Museum of Modern Art. He is a sculptor and the publisher of **It Is**, a magazine featuring works of "Abstract-Expressionist" artists. Pavia recently had his first one-man show at the Kootz Gallery. He is one of the founding members of The Club.

12. THE CRITICS AND THE MAGAZINES

To quote an old Chinese proverb, "One picture is worth more than ten thousand words." The relevancy of this time-worn phrase to the painting and sculpture of the "New York School" is quite simply affirmed by the work of art in its rejection of the old visual forms and symbols of storytelling and words. Communication between artist and public is not transmitted via objects or people depicted in the work, but by the very presence of the work itself.

The critics of the new art are writers whose criticism attempts an explanation and evaluation in symbolic (word) form of paintings and sculpture whose first premises are a rejection of these very symbols. This paradox has opened a wide rift between American art critics.

On the one hand are the critics for the two outstanding art magazines in America, whose readership is largely composed of artists, and on the other hand are the critics who voice the reactions of the Establishment in the popular media. Chiefly characterized by an "interested sympathy" in current painting and sculpture, *Art News*, which is widely circulated, numbers several painters among its contributing critics. Its monthly reviewing section is the only complete catalogue of the current exhibition scene, and the back of the magazine is devoted to a miscellany of timely pieces on such divergent topics as the art of Han China or the standards of morality that must be upheld by museum curators. Younger partisans of the new art are the magazine *It Is*, whose lavishly colored pages primarily illustrate the work of the first generation of "Action Painters," and a newspaper of all the arts called *Scrap*, whose slogan changes weekly (its second was "New York's Bulwark Against Time"). Together with the writings of a few independent critics whose work appears frequently in

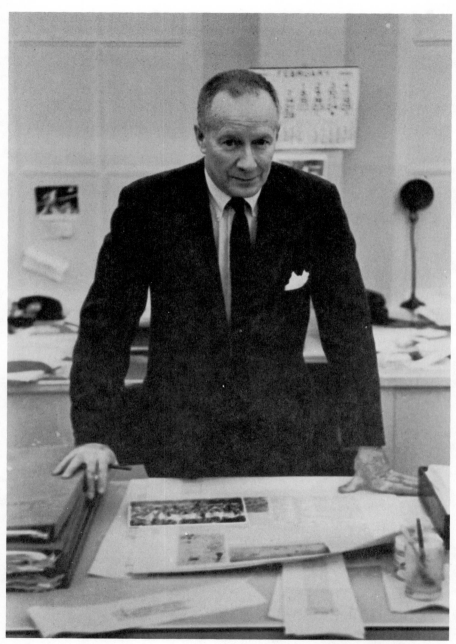

John Canaday, art critic for **The New York Times**.

art and literary magazines, and less frequently in popular maga-zines, the work of the sympathizers has not yet to any appreciable degree infiltrated the bastions of reaction.

Opposed to those who approve are those who violently dis-approve. It is this group which, confronted by the tremendous vitality of the new art, has chosen the path of least resistance in the critical dilemma by making a fairly sweeping condemnation of the movement, with a perfunctory bow, perhaps, to the talent of its founders.

The artists are caught, then, in the middle of this rift. Upheld by those who sympathize with their art but lack the wide circu-lation to make their views prominent, opposed by the critics who don't sympathize but command the ear of the public, the artists, with thinly disguised unconcern for the "to-do," continue to paint as they please.

Hilton Kramer, editor of **Arts** magazine, has written on art for **The Reporter, Commen-tary,** and **Art International.**

Right, Columbia professor, art historian and critic, Meyer Schapiro has written books on Cézanne, Van Gogh and Seurat/ Below, Clement Greenberg and wife, Jenny. He was a prominent critic of avant-garde art during the '40's, wrote weekly column for **The Nation**. His latest book, **Art and Culture**, is a collection of critical essays.

Harold Rosenberg has been a contributor to leading American literary and art publications. His work first appeared in **transition** and poetry magazines in the '30's. He and Robert Motherwell founded **Possibilities** in 1947. Rosenberg also lectured on literature at the New School, wrote extensively on action painters in **The Tradition of the New**. His latest book is on Arshile Gorky.

Top, James Schuyler, **Art News** reviewer, poet and author, takes notes from Neal Mallow at now-defunct Cedra Gallery, which was independently operated by the artist on Third Avenue/ Center, reviewers Schuyler and Sandler meet at an exhibition/ Bottom, Irving Sandler reviewing a 10th-Street show for **Art News**. He has also written for other art publications and for **Evergreen Review**.

Frank O'Hara exits from the Museum of Modern Art, where he is an Assistant Curator. O'Hara is the author of **Jackson Pollock**, a major study of this great artist's work. He has also had several volumes of poetry published. The recent exhibition of Spanish artists at the Museum of Modern Art was assembled under his direction.

Page 107: Hans Hofmann in his studio.

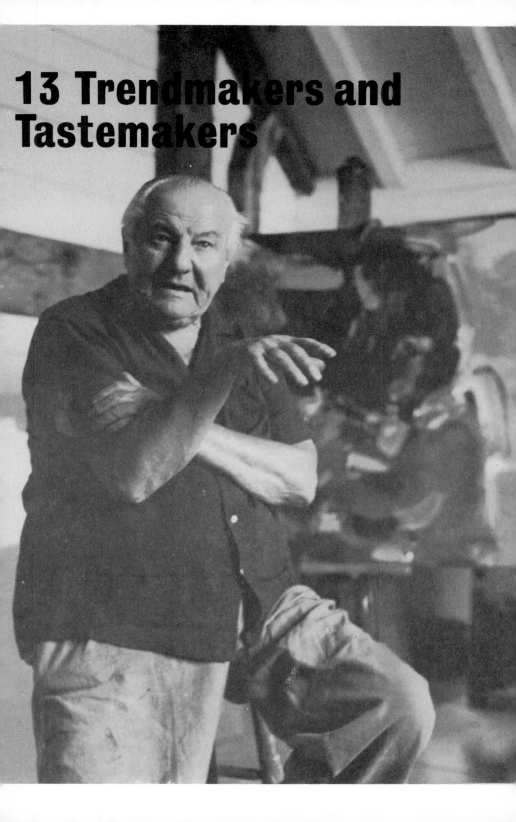

13 Trendmakers and Tastemakers

Left, sign at former Provincetown school/ Right, clean-up sink in classroom/ Below, Hofmann, in Provincetown; many of today's famous painters have at one time studied with him. He will be eighty-two on his next birthday.

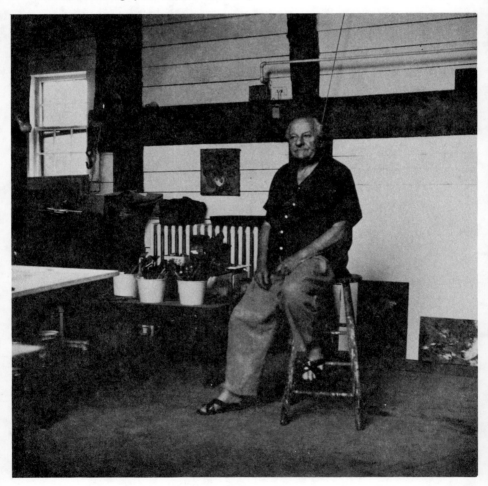

13. TRENDMAKERS AND TASTEMAKERS

As the crow flies, the distance from loft country to museum country is no more than about fifty city blocks. But paintings, unlike crows, don't take the shortest route. They travel, instead, through spheres of influence, slowly and circuitously.

The outermost sphere, the one that involves the studios where the work is actually being produced, is a complex relationship of three parts gallery to one part teacher. Teachers can detect and encourage an original talent, but only a gallery can sell the work. The interplay of ideas between an inspired teacher and an equally inspired student offers an enriching exchange to both. Though their artistic paths separate as the student matures into a personal realization of his own art, both readily acknowledge the force of the encounter.

The influence of the galleries is, of course, of great importance, for they can develop a market for his work that the artist might never find on his own. To say that the gallery is omnipotent would be rash. No matter how great its powers of persuasion, the gallery cannot, Svengali-like, mesmerize its clients into buying what they don't really like — or can they? Nevertheless, when a collector, seeing little merit in a particular work, has been lectured at length on its virtues by a reputable dealer, he usually buys. What he pays, of course, can range from one hundred to one hundred thousand dollars, depending on the size of the canvas, the painter, and the gallery. Naturally, if the dealer's reputation has been enhanced by successes with previous newcomers, his clients are more inclined to follow his advice on new talent. As a gallery's reputation grows, it enters that exalted circle where it might be included on an architect's list for recommending artists to execute a mural or a piece of sculpture for the lobby of a new building.

Collectors, of course, do have decided tastes and opinions of

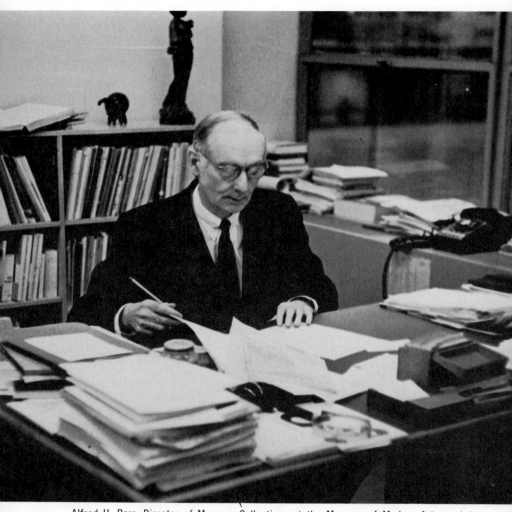

Alfred H. Barr, Director of Museum Collections at the Museum of Modern Art, went to Princeton, has been with museum since it opened in 1929. He taught art history at Vassar, Harvard, Princeton. Has directed a total of ninety-one exhibitions, and is editor and author of forty museum publications.

Lloyd Goodrich, Director of the Whitney Museum of American Art, has been with museum since its founding in 1930. He studied at the Art Students League and the National Academy of Design. He has lectured extensively and has written biographies of Winslow Homer and Thomas Eakins, and monographs on Ryder, Kuniyoshi, Weber, Sloan and Hopper.

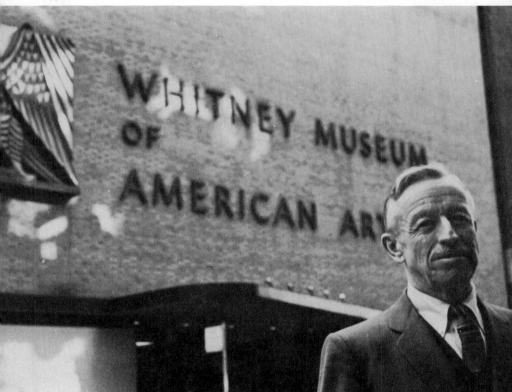

their own. Aside from the possible financial gain resulting from buying art whose worth could increase many times over in his own lifetime, the art collector, like most other hobbyists, simply enjoys the fun (and often passion) of collecting. Naturally, there is always the danger of the collector's acquiring a museumful of paintings. When he finds that his hobby has assumed the proportions of a public trust, the collector will often turn his collection over to the public. Then with his own walls invitingly empty, he can start all over again!

A museum is not only a public trust, but it is also an educational institution. Education includes an evaluation of the present as well as the past. Museums, therefore, have necessarily taken on the courageous role of exposing the public to the art of its own time that, in the museum's opinion, will outlast the moment. Inevitably, the limited size of the museum's scouting staff considerably reduces the chances of its finding an artist whose work has been completely unheralded by collectors, critics, or dealers. And since a museum is hardly infallible, it may now and then exhibit the work of a "promising" artist, whose later work will prove a disappointment. When all is said and done, however, no artist could ask for a greater accolade than to have his work exhibited by a museum and included in its permanent collection.

Above, Curator of Museum Collections, Dorothy Miller, of the Museum of Modern Art, has directed the series of exhibitions of young Americans. The most recent "16 Americans" show brought to 140 the total number of artists shown in this series/ Below, James Johnson Sweeney, formerly associated with the Guggenheim Museum, recently became director of Houston's Museum of Fine Arts.

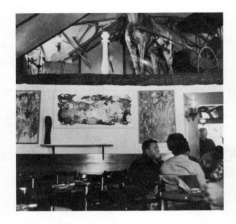

Left, painting collection of Meara and Reginald Cabral at their Atlantic House Jazz Club in Provincetown/ Right, part of the great collection of Walter P. Chrysler, Jr. is housed in a former Provincetown church that is now a museum/ Below, New York dentist Meyer Pearlman both buys and exchanges his dental services for paintings, has a vast collection in storage. Painting by Taro Yamomoto is on wall.

Above, fabric manufacturer Ben Heller broke down two walls in his apartment to provide effective hanging space for his collection, which includes paintings by Pollock, Guston, Rothko and Kline. Heller has written and lectured on art/ Below, stockbroker Walter K. Gutman, author of the famous **Gutman Letter**, is a former art critic and has himself exhibited paintings. He collects Kline, Goldberg, Leslie, Miles Forst and others.

Galleries are generally named after the dealer-owner. Top, Samuel Kootz, right, Stephen Radich, and below, André Emmerich.

1

Above right, Sidney Janis/ Center, Martha Jackson in brocade at left and Rosalind Constable of Time, Inc./ Bottom, John Meyers of Tibor de Nagy Gallery with author-critic Robert Rosenblum, center, and Gene Vass at left.

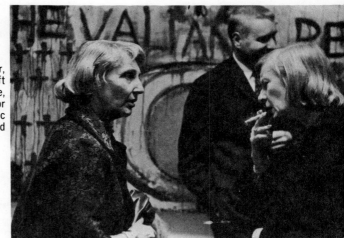

Left, Eleanor Ward, at former Stable Gallery. Behind her is writer Richard Baker, and painter Edward Avedisian at left/ Right, Leo Castelli/ Below, Ellie Poindexter, seated with Conrad Marca-Relli, left, and Ludwig Sander, right, with painting by James Brooks on wall.

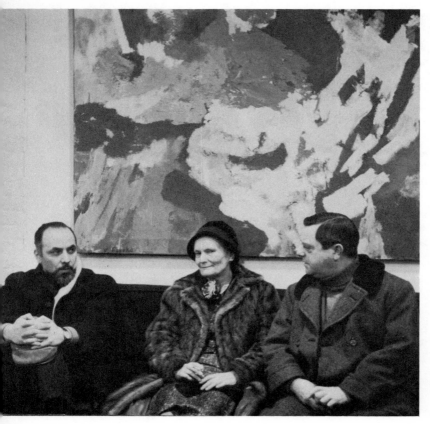

11

Part 3
A Definite Stand

14 From Impressionism to Expressionism

14. FROM IMPRESSIONISM TO EXPRESSIONISM

Artists don't like labels. Even the seemingly innocuous term, "New York School," has a perverse way of classifying a great many painters in a category that they not only don't like, but also don't belong in.

It's the critics, of course, who have been coining the terms with which to categorize the artists. Few of these terms are approved by the artist who, upon hearing what a critic thinks he is, invariably rejoins, "But no, that is exactly what I am *not.*" Some phrases in particular have become standard, such as "Action Painting," "Abstract Impressionism," and "Abstract Expressionism." Their continued use may be attributed more to their appeal to a public that has at least heard these words before (if in different contexts) than to their popularity with artists.

"Generation" is another epithet vehemently decried by the artists. Understandably, the critics have been at a loss to pinpoint the various segments of the art community. Their categories start with the first generation, or founders. In the space of a dozen years, of course, a second, third, and fourth generation have also arrived on the art scene. The absurdity of "generation" categories was aptly lampooned in the Summer, 1956, issue of *Art News* like this: "(age) 0-23, (appelation) Art student; 24-39, Young; 29-51, Younger; 42-64, Older (generation); 33-57, Veteran (exhibitor, Surrealist, etc.); 38-69, Pioneer (Realist, Abstract-Expressionist, etc.); 64-100, Master (also means dead seven or more years)."

Obscured but undaunted beneath the arbitrary, ill-fitting labels are the artists, who refuse to enter into any unholy pact with their explicators. "We agree to disagree" was the artistic premise of The Club. The motto is still applicable.

Their art is individual and personal, as all art must be. Their

background is the heritage common to all artists, everywhere, with their closest ties related to the most recent masters, the French schools from Impressionism to Cubism, and the German Expressionists. They share in the growing Western awareness of the art and philosophy of the East, and have felt the excitement of anarchy expressed by the Dadaists and Surrealists.

Their experience, up to a point, has also been a common one. With other Americans of their era they lived through a Depression that forced a consciousness of social conditions on all Americans. They lived through a war that not only made them aware of the insularity of previous American artists but also brought to America refugees from all over the world. Some of those refugees were the artists who helped revitalize the ever-present interest in abstract art in the United States.

While influences from the outside may have been felt more or less in common, each artist's absorption of these influences into his own work has been highly individual.

Clyfford Still (r) and Ernest Briggs caught off-guard on West 21 Street.

121

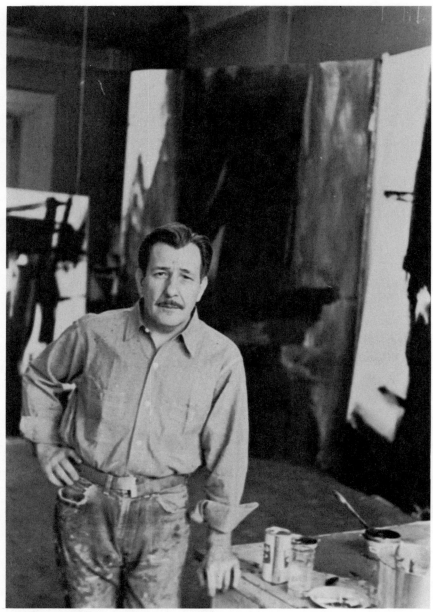

Franz Kline, above, was born in Pennsylvania in 1910, worked in realistic style until 1945.
Did barroom murals in '40's that were recently exhibited, is famous for black-and-white
abstract calligraphic paintings. He exhibits at Sidney Janis/ Right, Willem de Kooning
and Jack Tworkov. De Kooning was born in Holland in 1904, and studied art in Rotterdam.
He worked as a house painter, display artist, and, like Kline, painted bar murals. Was on
WPA art projects and painted World's Fair murals in 1939. He also is represented by
Sidney Janis. Tworkov also worked on WPA art projects. He shows at Castelli. All three
were Club founding members.

Page 119: Franz Kline and Willem de Kooning on 57th Street.

Mark Rothko was born in Russia in 1903, came to the United States ten years later and began to paint in 1926. He went to Yale, worked on WPA, and studied at the Art Students League with Max Weber. Shows at Sidney Janis. A retrospective exhibit of his paintings was held recently at the Museum of Modern Art.

Philip Guston is from Montreal. He began working in abstract style in 1948. He has paint-
ings in the collections of the Museum of Modern Art, the Whitney and other museums.
His dealer is Sidney Janis.

Robert Motherwell, left, studied art at Stamford University, did graduate work in philosophy at Harvard and in architecture at Columbia. In 1947 was editor, with Harold Rosenberg, of avant-garde **Possibilities** dealing with problems of contemporary art. He was also a founder of "Subjects of the Artists." Exhibits at Sidney Janis.

Milton Resnick, below, was born in Bratslav, Russia, in 1917. He studied at Pratt Institute in Brooklyn and with Hans Hofmann. He has 5000 square feet of studio space, and paints canvases as large as 117" x 237½". He exhibits at Howard Wise.

Right, James Brooks and John Ferren (foreground). Brooks was raised in the West and worked on WPA mural projects in 1938. He has taught at Columbia, Pratt and Yale. Ferren comes from Oregon and had one-man shows in the '30's. Both have exhibited internationally.

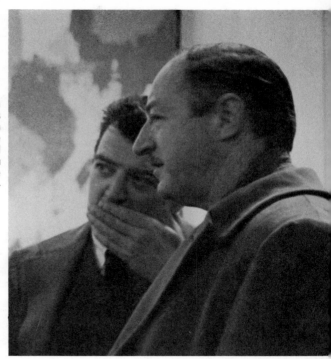

Sam Francis has a Master's Degree from the University of California and now spends most of his time in Paris. Has exhibited internationally since 1950. Blanche Phillips, sculptor, is at right/ Adolph Gottlieb, below, was born in New York, 1903, studied at Art Students League and had first one-man exhibit in 1940. He is represented in several museum collections.

William Baziotes, above, is from Reading, Pennsylvania, and came to New York in 1933. He taught on WPA art project. His first one-man show was in 1944 at "Art of This Century." He has exhibited with Kootz and is now with Sidney Janis.

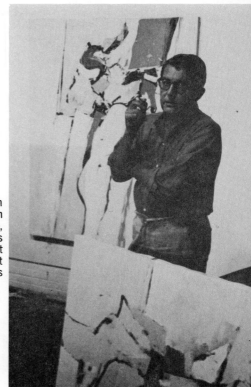

Kyle Morris, born in Des Moines in 1918, graduated from Northwestern University with Master's Degree, studied painting in Chicago. Has exhibited in one-man shows at Walker Art Center, Des Moines Art Center, Stable and Kootz Galleries and in Milan.

Above, Denise and Ray Parker. Parker comes from South Dakota, studied art history at the University of Iowa, and has published articles in **It Is**/ Enrico Donati, left below, comes from Milan, has had 17 one-man shows since 1942. He is with Parsons/ Giorgio Cavallon, below right, is an Italian who came to America in 1920. He was one of Hofmann's pupils. Cavallon now exhibits at the Kootz Gallery.

Herman Cherry is represented by Ellie Poindexter. Cherry also teaches and has written extensively on art.

Paul Jenkins came from Kansas City, Missouri. He started painting while in Navy Air Corps in 1944 and later went to the Art Students League. He has lived abroad on and off since 1953; shows at Martha Jackson.

New Yorker Nicholas Carone, above, was born in 1917 and studied at Art Students League and elsewhere. He shows at the Stable Gallery and is represented in museum collections/ Hyde Solomon, below, is a New Yorker born in 1911. Studied painting and sculpture at Pratt Institute. He shows with Poindexter.

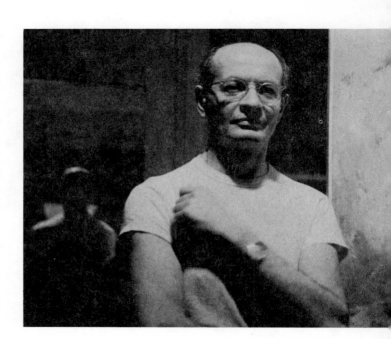

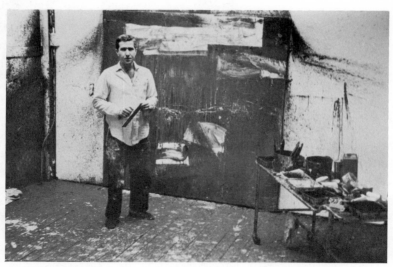

Michael Goldberg is also a New Yorker. He has been painting since 1939 and studied with Hofmann in 1941.

Theodoros Stamos, left, had first one-man show in 1943, now shows at Emmerich/ Matsumi Kanemitsu is with the Stephen Radich Gallery, and has had a number of one-man shows.

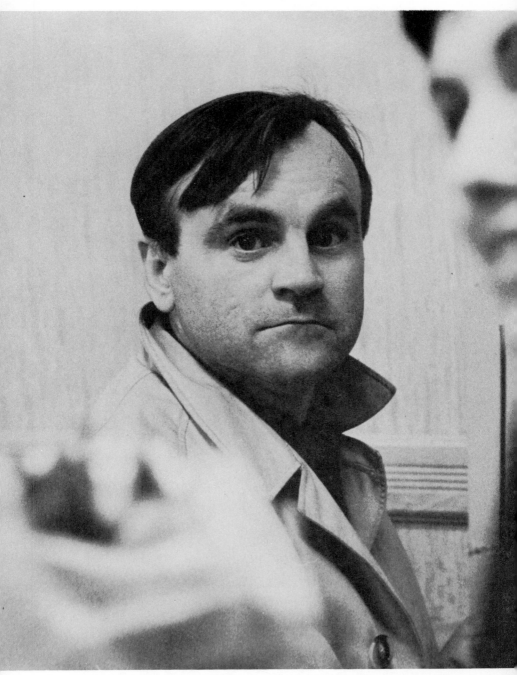

Felix Pasilis comes from Batavia, Illinois, and studied with Hofmann. He exhibits at Dick Bellamy's Green Gallery.

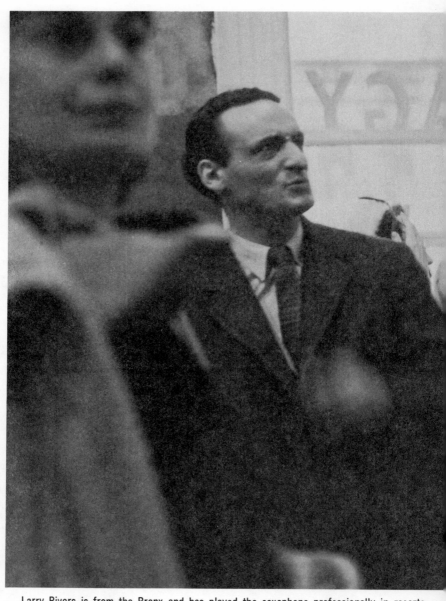

Larry Rivers is from the Bronx and has played the saxophone professionally in resorts. He began painting with Hofmann in 1947. He exhibits with Tibor de Nagy.

Lawrence Calcagno and Angelo Seville, center. Calcagno was represented in the Brussels World's Fair and has had one-man shows at the Martha Jackson Gallery.

William Littlefield, below left, graduated from Harvard, and studied abroad during the '20's. He exhibits extensively in 10th Street/ Al Kotin, below right, has taught at Pratt, and has also had one-man shows in 10th Street.

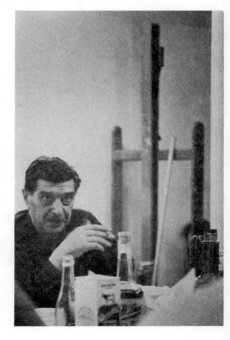

Mario Yrisarry (from Manila), Athos
Zacharias, George Preston and Joe
Clark with Burt Hasen. All started
showing work in 10th-Street
Galleries.

15 The Sculptors

Page 139: Welding shop of sculptor Abram Schlemowitz.

Details of works by four sculptors: above left, Copper and Bronze by Schlemowitz; right, Tin by William King; left below, Wood by Louise Nevelson; right, Terra-Cotta by Reuben Kadish.

15. THE SCULPTORS

Just as the epic-making discoveries by physicists of the nature of light inspired the exploration of the effects of light in 19th-century French painting, so the marvels of modern technology have given the sculptors of today a new world of materials and methods to explore.

In the golden era of classical Greece a sculptural apotheosis was realized in the great marbles and bronzes exalting the beauty of the human form. This same classic ideal was the inspiration for the giants of the Renaissance and such modern masters as Rodin and Maillol.

Now, however, marble and bronze and the classic ideal are no longer the chief components of sculpture. We are experiencing a renaissance in sculpture as an art form as artists call on new ideas, on new abrasing methods, and turn to a wide variety of metals, such as copper, steel, tin, and iron, as the raw materials for their art. Originality with these metals is creating a new sculpture of unearthly beauty and genuinely exciting qualities. Not only raw materials, but "found objects," such as scrap metal, machinery, sticks, and all sorts of *junk*, are also becoming part of this new art, as artists experiment with the unexpected and unusual beauty found in everyday objects.

It is worth noting that the would-be sculptor has always been faced with a more serious financial problem than the painter. Marble and bronze and fine blocks of wood are expensive materials that can be ruined by a bad slip on the part of the artist. It is difficult, if not impossible, for the sculptor to "erase" his mistakes as the painter can. Likewise, the outlay for new tools and materials for modern sculpture still far exceeds the costs of paint and canvas. A sculptor who works with metals, whether it be copper, steel, or tin, must be equipped with the equivalent of a

Above left, Peter Grippe who works in cast bronze and welder Martin Craig, right, at The Club/ Left, welder David Weinrib and John Chamberlain, right, who works in welded metal from "found objects." Weinrib had first one-man show at Howard Wise. Chamberlain shows at Leo Castelli.

Metal-welders, Seymour Lipton and David Slivka, right. Lipton is a retired dentist and comes from the Bronx, is represented in more than a dozen museums. Slivka comes from Chicago and has taught at four universities.

welding shop in his studio, and he cannot count on turning a profit on his work to help amortize the cost of his investment.

One of the newest, most fascinating developments in sculpture is the idea that a work of art is not only to be seen from all four sides on the outside, but that it should also be possible for one to view it *from the inside* as well. And so an "environmental sculpture" has been achieved — huge pieces filling a room that are intended to form an environment for living. This is but one of the many exciting forms taken by sculpture today — sculpture that once again has become a vital, important force in the world of art.

Herbert Ferber's "Sculpture to Create an Environment "

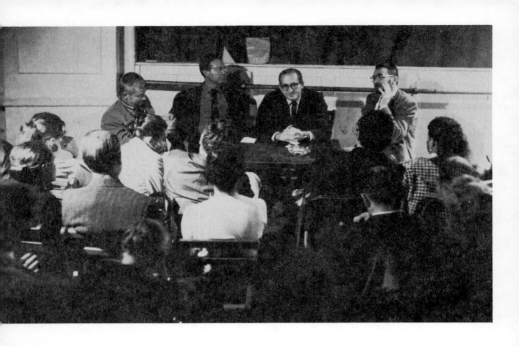

Above, sculptors Wilfred Zogbaum, Ibram Lassaw, writer Emanuel Navaretta and Sidney Geist in a Club discussion on "Who Owns Space?" Geist publishes **Scrap**, a weekly art sheet, works with various metals. Zogbaum and Lassaw are welders/ Robert Mallary, below, uses "found objects" treated with plastics. He comes from Ohio, is forty-four, and studied in Mexico City and Boston.

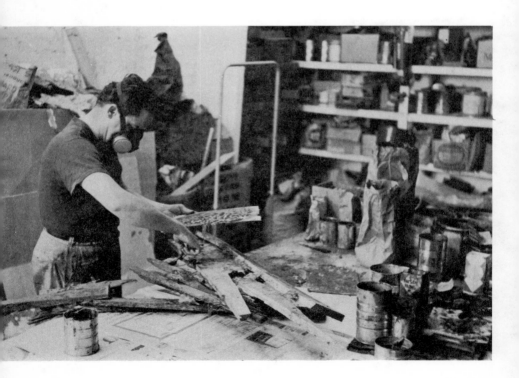

Right, New Yorker Abram Schlemowitz demonstrates welding in his workshop. He works chiefly with metals and is founder of the "New Sculpture Group," which exhibits annually. He shows at Howard Wise/ David Smith, left below, is the dean of sculptor-welders, constructs in wrought iron, stainless steel, and silver, and has exhibited internationally/ James Rosati, right, works in fabricated metal. He began as a violinist in Pittsburgh, worked on WPA art projects, and came to New York in 1943.

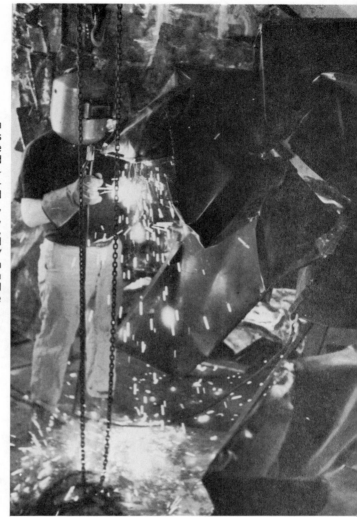

Frederick Kiesler came to the United States in 1926 from Vienna. He is an architect-sculptor. In 1923 he proposed the first actual shell house in history. It is an egglike construction balanced on stilts, called the "Endless House." He is the architect of World House Galleries, and recently showed working models of his "Endless House" at Castelli. Harold Rosenberg is at right.

Ann Arnold does expressionist wood sculpture of animals.

Peter Agostini, right, works in direct plaster, comes from New York's "Hell's Kitchen." He has had only one year of formal art training; shows at Radich. Behind him is painter Clifford Smith.

Tom Doyle, above, is shown building a sculpture from fabricated wood. The finished structure can be viewed from all angles. He has worked only with wood. His first one-man show was recently held at the Allen Stone Gallery/ David Hare, right, works in metal. He did color photography prior to 1941; his sculpture was shown first in 1944 at Peggy Guggenheim's "Art of This Century Gallery." Noguchi, who mixes media, is in the background.

Gabriel Kohn works in fabricated wood. He studied in New York and Paris, and has exhibited in France, Italy, England and Germany; now shows at Castelli.

Israel Levitan, a wood carver, studied with Ozenfant and Hofmann and has also taught at Cooper Union. Levitan has used some of New York's old Third Avenue El ties as material for his sculpture; is a former prizefighter. He shows at Barone.

Ruth Vodicka, demonstrating oxyacetylene welding process on steel structure of welded bronze and brass sculpture. Blowtorch heat is 6000° F./ Below, is an example of a direct metal sculpture by Richard Stankiewicz at the Stable Gallery. Behind sculpture is painter-sculptor Bernard Langlais who shows with Castelli.

150

16 Women in Art

Page 151: Artist Ruth Kligman on University Place. She has shown in group shows on 10th Street.

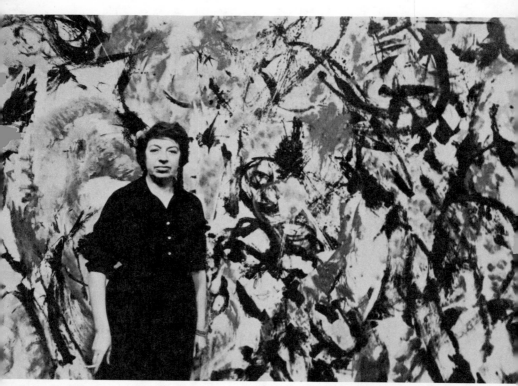

Lee Krasner is Jackson Pollock's widow. They met in 1940, when both exhibited at the McMillan Gallery in New York, and were married in 1944. She has had one-man exhibitions at Parsons, The Stable, Jackson, and Wise. Krasner comes from Brooklyn.

16. WOMEN IN ART

From time to time there appear in national magazines a number of articles on "women in art." While the magazines may single out four to seven such artists, they invariably choose the same names. The range and vitality (and existence) of the hundreds of competent women artists in America is completely overlooked.

In the last twenty years there has been an increasing number of women artists who deserve serious attention. Although the number of male artists has also grown considerably in this time, the number of women artists, by comparison, has increased a hundredfold.

Why is it that women have been so long in taking up the brush — or welding torch? The obvious answer is that welding and painting have been outside the usual range of women's concerns. Painting is a messy business and has little in common with such housewifely virtues as neatness and cleanliness. Literature has always been considered a more ladylike art. Writing doesn't require a woman to move large canvases from floor to easel or manipulate heavy stones or logs.

So, until World War II women were comparatively rare in the fields of painting and sculpture. But the war created a great demand for women in factories and business offices, and the emancipation came. It came to a generation of women whose mothers were perhaps the first in history to instill ideas wider than *kinder, kuchen, und kirche.* The vote was granted to women in the second decade of this century, but it is their children who have felt the full effect of this emancipation.

With this freedom has come the problem that besets any career woman today. Women still want marriage and children. Women artists find themselves in competition with young men in their field, and should artists marry, this sense of competition may well

prove a great strain. Marrying outside the field of art offers the same difficulties other career women face, with the added likelihood that husbands will be inclined to take an unserious attitude toward their wives' art.

The genuinely exciting talent displayed by women artists today is earning the well-deserved respect of fellow artists and critics, and it is inevitable that their contribution to contemporary art will become even more important in the future.

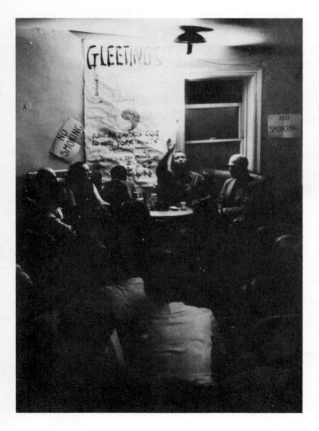

Club Sculpture panel (l to r) Reuben Kadish, Dorothy Dehner, Herman Cherry, Louise Nevelson (also above) and Peter Grippi.

Marisol (Escobar) was born in Paris of Venezuelan parents. She studied art in Paris, Los Angeles and New York. Painted prior to 1954. Her sculptures of families and cats were recently exhibited at Janet Keyishian's Great Jones Gallery.

Above, Elaine de Kooning is seen painting her pillar collages/ Below, Elaine de Kooning in her 5000-square-foot studio on Spring Street is arranging her architectural cylindrical paintings 10½′ high. Collages can be arranged and rearranged to change axis and cause astigmatic images.

Above, Grace Hartigan with dealer Tibor de Nagy. She was born in Newark in 1922, recently moved to Baltimore. Her work is in the collections of the Museum of Modern Art and Whitney Museum, and was included in "The New American Painting" exhibit shown in Europe, 1958-1959/ Below, Pat Pasloff recently had a one-man exhibition at Green Gallery/ Right, Helen Frankenthaler graduated from Bennington College and is married to painter Robert Motherwell. She studied briefly with Hofmann.

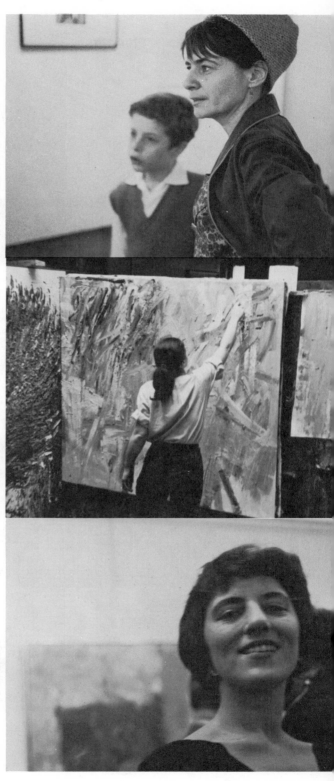

dy Müller, on opposite page, was
member of Hansa Gallery group
fore it closed, was married to
inter Jan Müller, who died in
58.

Edith Schloss is married to pho-
tographer Rudolph Burckhardt. She
was formerly an associate editor
for **Art News**. Schloss has shown
at Tanager on 10th Street.

Joan Mathews, seen working with
a palette knife, comes from the
Midwest, where she studied at
Indiana University. She is married
to sculptor Abram Schlemowitz.

Dore Ashton, former art critic of
The New York Times, recently won
a Ford Foundation Fellowship to
study European and American art-
ists. She is married to painter Adja
Yunkers.

Joan Mitchell, center, at R. T. French & Co., with poet-playwright Joseph Le Sueur and dealer Bertha Schaefer. She exhibits at the Stable Gallery/ Below, sculptor Jean Follett and Dick Bellamy, director of the Green Gallery/ Right, fashion model and painter Jane Wilson comes from Iowa and shows her work at Tibor de Nagy.

Alice Neel with her model Antonia Encarnacion. Neel has also painted portraits of Jim Cuchiara, Frank O'Hara, Hubert Crehan, Milton Resnick and Pat Pasloff.

Minna Citron is a veteran painter and world traveler. Her son Casper conducts an FM radio program on the arts.

17 New Images and
the Hard Edge

Page 163: Landes Lewitin in the Rose Fried Gallery. He was one of "16 Americans" ex-
hibited at Museum of Modern Art. He was born in Cairo, Egypt, and studied there, lived
in France for eleven years. Lewitin came to the United States in 1939, showed in late
'40's at Egan Gallery.

Paul Georges in his studio on Broadway. He recently taught in Colorado, has shown in both
uptown and downtown galleries. At the Great Jones Gallery he showed fifteen self-portraits.

17. NEW IMAGES AND THE HARD EDGE

Of all the currents in modern art, the most unlikely, Purism, has had the widest effect on everyday life. As the art furthest removed from literal representation, Purism was developed about 1917 by a group of Dutch artists who called themselves "de Stijl" ("the Style"). The "de Stijl" group felt that the most abstract art of that time — Cubism, which had broken the appearances of reality into their simplest forms — had not gone far enough. Divorcing their art entirely from representation, they composed in terms of geometry and mathematics. The group, as an entity, lasted less than a decade, but its influence pervades our lives today.

Further reinforcement of their influence on American art came during World War II when leading exponents of Purism came to the United States as refugees.

The clean, hard edges and pure, primary colors of Purism have been integrated into all areas of our life. The placing of bookcases on a living room wall, the office partitions constructed of alternating rectangles of white and colored plastic, page layouts in newspapers and magazines — the list is endless.

Running directly counter to the Puristic strains of modern art is the trend concerned with figures and images. Without actually returning to any naturalistic representation, this group may be characterized by its concern for symbols. When these symbols are human ones, they are distorted in a way that clearly indicates a picture of man, not as he appears on the surface, but as he is within his soul. The figures are larger than life in the sense that one element of humanity, fear, for example, is accented so as to be in complete control of and dominate the image. This stress on symbols of distortion has always been a basic trait of primitive art, and the roots of the modern movement in images can be fairly directly traced back to the beginnings of art. The influence of

165

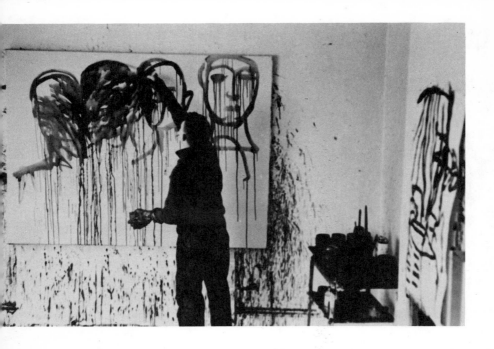

Lester Johnson, above, demonstrates his technique in his 10th-Street studio. Johnson is forty-two, comes from Minneapolis, has exhibited with Hansa and Zabriskie/ Below, Bob Thompson, left, with Jay and Sheila Milder. Both Thompson and Milder have shown together at Zabriskie and have participated in Happenings at the Reuben Gallery.

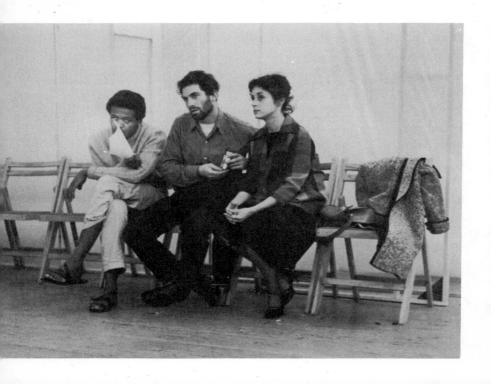

Surrealism is clearly evident, also, in those paintings of mystical conception and nightmarish atmosphere.

Obsessed and articulate, the work of this group has shown a growing strength in recent years. More and more artists have found this way of painting to be one that can best express their feelings about the world they live in.

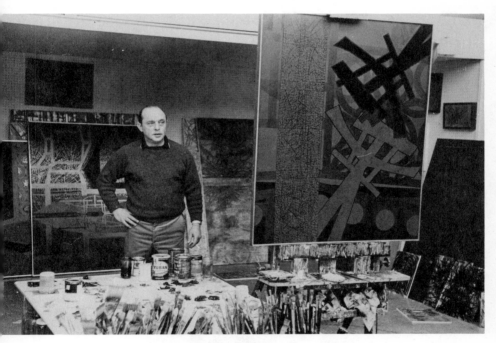

Jimmy Ernst in his East Hampton studio.

Balcomb Greene, right, stopping off for dinner at the Cedar Tavern. His figure paintings have been exhibited at Bertha Schaefer and, most recently, at the Whitney Museum / Center, Ada and Alex Katz. He has worked as a house painter, frame carver, carpenter and teacher. Katz shows at the Stable Gallery / Bottom, Harry Jackson visiting the Henry Street Playhouse for a dance recital. He painted abstractions until 1954, was married to artist Grace Hartigan, now does bronzes of cowboys and cattle.

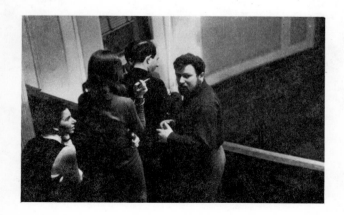

168

Aristodimos Alpha Atarneus Melandino Kaldis, painter and writer, lectured at The Club on the subject of "The American Artist as Magician, Healer, Outcast, Redeemer and Savior."

...land Bell, below, reading with Jane Freilicher. ...r husband, Joe Hasen, is at right.

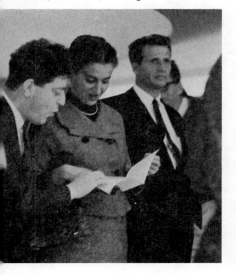

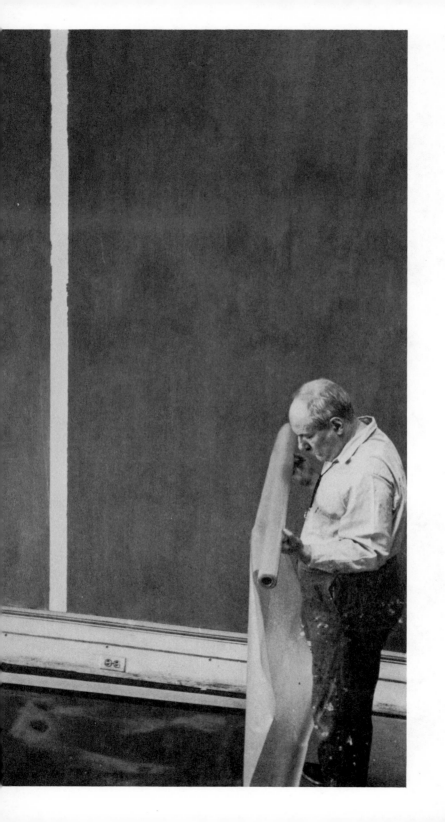

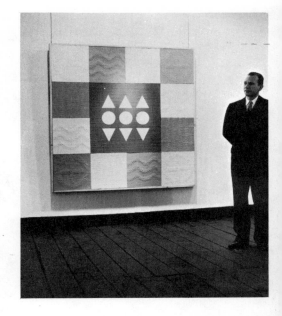

nett Newman, opposite page, was among early bstract-Expressionists." Had retrospective at F. French & Co. in 1959. Newman was a under, with Motherwell, of "Subjects of the sts," the school and club on 8th Street.

George Ortman, above, studied in Paris under the GI Bill, and with Hofmann. Had first one-man show in 1954, and is represented in the Museum of Modern Art/ Below, Frank Stella born in Massachusetts in 1936, graduated from Princeton in 1958. He shows at Castelli.

ove, Ilya Bolotowsky, painter and teacher, also oduces abstract films, has exhibited at Stuttman d Borgenicht/ Below, Leon Smith, who has own at Parsons Section Eleven.

71

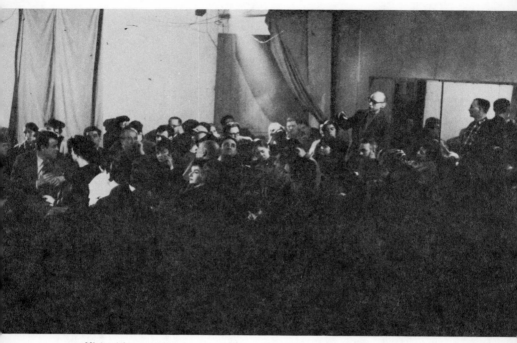

Michael Loew addressing panel during "Hard Edge" discussion at The Club.

Alice Mason is a "pioneer" abstractionist, who
has shown her work at the Stuttman Gallery. She
is the mother of Emily Mason, also a painter.

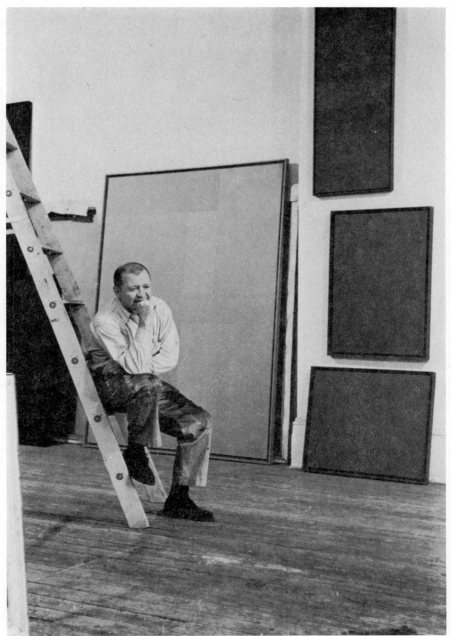

Ad Reinhardt had a retrospective exhibition last season at the Betty Parsons Gallery, showing twenty-five years of his abstract art. He was born in Buffalo in 1913, and went to Columbia University. He is a self-taught painter and exhibited with American Abstract Artists from 1939-1946.

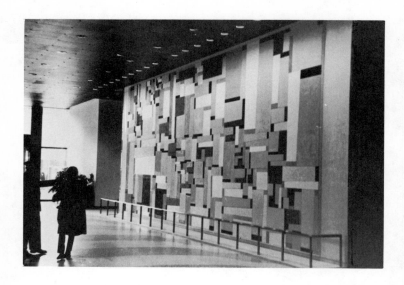

Above, painting by Fritz Glarner in the lobby of the new Time-Life Building. The theme of the painting is "the rhythm and movement of the city"/ Below, Earl Kerkam is seen sitting in Sidney Frane's framing shop on 10th Street. Kerkam recently had a one-man show at World House Galleries.

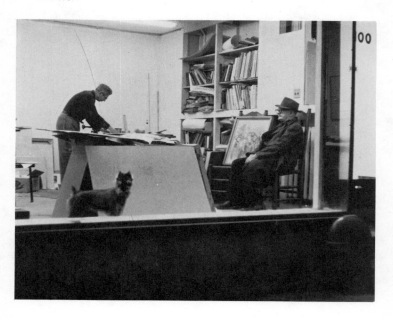

18 Experiments with Junk

18. EXPERIMENTS WITH JUNK

Outraged cries of "child's play" and "baloney" have characterized the advent of new art forms since the early nineteenth century. Through the following decades charges of villainy and fraud have been leveled at new theories advanced by young artists. But the *avant-garde* of one era becomes reaction in the next.

In the 1920's Dadaism was *le dernier cri,* and quite a *cri* it aroused in the press and the art world as young men demonstrated their loss of faith in the generation that had brought on World War I. They published manifestoes demolishing the current shibboleths in painting and music and literature. Dadaism was the anti-art outburst of disgust at the futility of all art, with destruction, even self-destruction, its anarchic foundation. Common objects like a grater, a coffee pot, and a pencil were put together and flung, as art, in the face of a predictably outraged public.

Born out of Dadaism, Surrealism was a more positive protest for freedom in art. Its innovators were strongly influenced by Freud's emphasis on the unconscious mind, and the world of dreams was recognized as a source for art. In touch with the psychological findings of its time, Surrealism was also aware of politics and sociology.

The echoes of protest from Dadaism, flowing into an awareness of the human condition are coalescing today in a new group of young men and women. Like those who experimented with Dadaism after World War I, this post-World War II generation is outraged by conditions in the world today. Their world blindly endorses the value of obsolescence as it engages in a mad race to manufacture a hideous mass of shiningly ugly rubbish destined, fittingly enough, for the junk heap.

This generation sees and is appalled. Their work can be inter-

preted, partly, as a prophetic social message with its perishability proclaiming, louder than any megaphone, the futility of the race. Their constructions may hang from the ceiling like monolithic mobiles, protrude from the wall like a painting gone amuck, or stand or lie on the floor. From the rubbish heap of the city pieces of machinery, rags, scrap metal, sticks, bricks, newspapers, clothing, and furniture are combined in a variety of ways and splashed with paint in a brutally direct way.

As perishable as these constructions are the theatrical events called Happenings, conceived and performed by this same group. In a period of a few minutes an event is born, lives, and dies, presenting an analogy closer to life than a conventional play or painting.

* * *

From Impressionism to Expressionism, from Purism to a re-emergence of images, from marble to junk, the counterpointing movements of contemporary art strike a resounding, vigorous chord of life.

Pop Art followed The New York School in the early 1960's with the emergence of (l to r) Tom Wesselmann, Roy Lichtenstein, James Rosenquist, Andy Warhol and Claes Oldenburg.

Kaprow at the Reuben Gallery directs placing of wood frames, separating rooms. Space was divided up according to strict floor plan. A Happening took place in each room.

Page 175: Rosalyn Montague assisting in Alan Kaprow's presentation of "Eighteen Happenings in Six Parts."

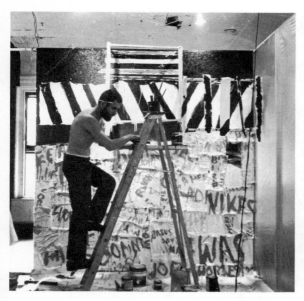

Kaprow building a wall collage from ripped canvas, pasted together and painted over in separate parts. Plastic film at right divided areas but permitted cloudy vision of the Happening in the next room.

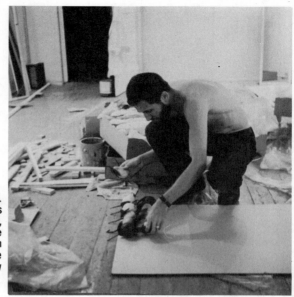

Artificial fruit being mounted on boards. Some other props for the Happenings were flashing Christmas lights, mirrors, dancing toys and juice squeezers. Some of the scenes from Kaprow's "Eighteen Happenings" were meant to give the jumbled impression of a stroll on New York's 14th Street.

Page 180: Allan Kaprow behind his "sandwich man" machine. When machine is on, lights twinkle, bells ring, and a record inside plays garbled sounds. This artist contends that "anything goes" — any object, any theme whatsoever is valid material for artistic expression.

Completed "Fruit Stand" was set into wall frame and combined with torn newspaper clips, canvas, strips, rags, and individually painted pieces of paper to make up the entire collage.

Robert Whitman, left, and his audience during "A Small Smell," a "controlled performance in time to create a theatrical object." After the explosion of a sulphur stink bomb, the reaction among the artists gathered below was very mixed indeed.

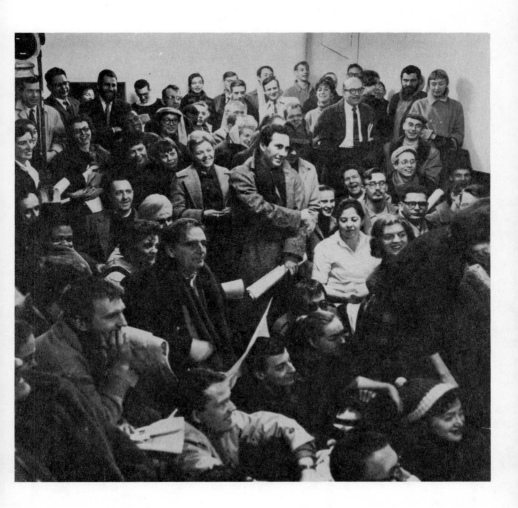

Front entrance of the Judson Gallery on Thompson Street during the "Ray-Gun" exhibit/ Below, a detail of the scene above showing the posters drawn by Claes Oldenburg and James Dine advertising "Ray-Gun." The slogan of the "Ray-Gun" series was "Annihilate-Illuminate." This exhibit and series of Happenings was described by the artists as being both "destructive and creative."

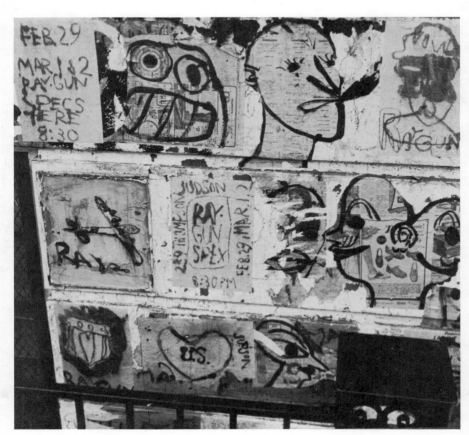

Left, Oldenburg as part of a "Ray-Gun" street during a performance of "Snapshots from the City"/ Right, a wall with window and head of "shoeshine man"/ Below, a typical corner of a "Ray-Gun" street. Materials in the experimental mural-like constructions, which derive from American popular and street art, include burned cardboard, tar, egg crates, paint, wood, old newspapers.

Red Grooms is seen above in action during a performance of "A Garden," a ballet by Marcia Marcus, with Bob Thompson playing the bongos. In this ballet Grooms depicted "the excitement of daytime." Boxing posters seen on the wall were cut up into flower forms. Performance was held at the old Delancey Street Museum. Grooms, at left, who comes from Nashville, opened the museum to show paintings and put on plays. Groom's own Happening called "Burning Building" was also performed at the museum.

George Brecht, below, and one of his "magic" boxes at right. The spectators participating in this particular form of artistic expression were permitted to investigate the kit, inspect all its contents carefully and even rearrange the objects if they so desired. The kit was a mixture of doctors' instruments, child's toys, blocks, a lollipop, mirror, jump rope, pick-up sticks. Brecht also composes music and has studied with John Cage at the New School.

Exterior of the Reuben Gallery on East 3rd Street during a performance of "The Car Crash" by James Dine/ Below, rolled linoleum and cardboard was sprayed ghostly white and left almost intact, thus becoming part of "bandage" background for this Happening.

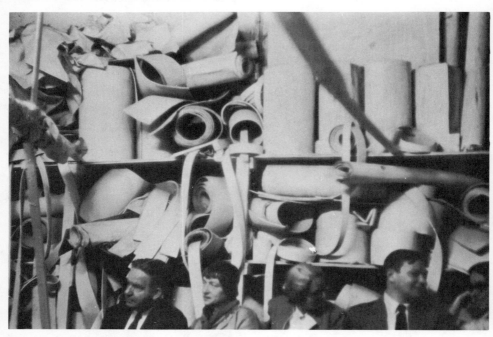

Dine, wearing metallic coat, sprayed face gray to blend colors and transform himself into an "aluminum car." By using real people instead of canvas, Dine achieved a more vital and dramatic expression of a car crash.

Above, sprayed satchel resembling a doctor's bag and a red cross in the background are all parts of the crash scene/ Below, limp limbs, intestines, and oxygen bags are symbolized by vacuum cleaner parts and BX cables.

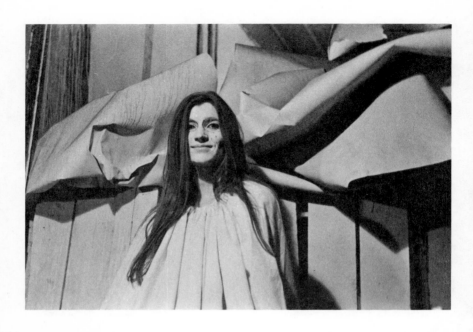

Pat Oldenburg, above, is the ominous, eight-foot-tall "Big White Woman," the immortal victim, the angel/ Below, Dine grunting and groaning in a final moment before "frustrated ecstasy." Board was used for "monster-car" drawings; "Help machine" is above Dine.

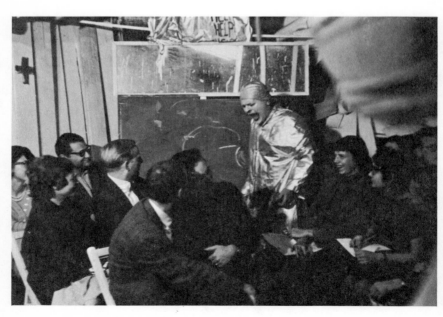

Jasper Johns, right, and Robert Rausch-
enberg, at bottom of page. Both men use
in their art such "found objects" as beer
cans, coke bottles, flashlights, etc. Johns'
"Painted Bronze" (1960), in the collec-
tion of Mr. and Mrs. Robert C. Scull, is
illustrated below. The work of both art-
ists is exhibited at Leo Castelli.

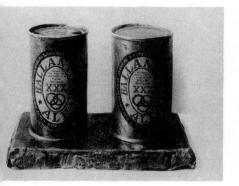

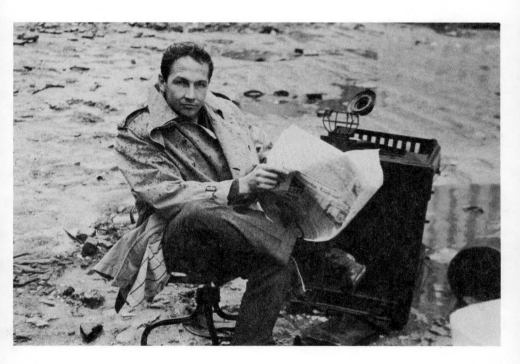

INDEX

Page 192: George Siegel's plaster man on a bicycle. He shows at the Green Gallery.

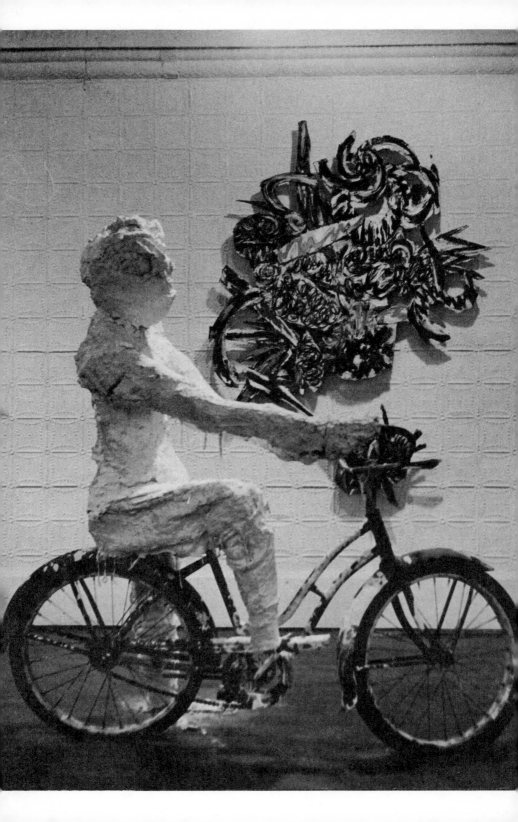

GENERAL BIBLIOGRAPHY

Alloway, Lawrence. *Topics in American Art Since 1945.* New York: W.W. Norton Co., Inc., 1975

Auping, Michael. *Abstract Expressionism — The Critical Developments.* New York: Harry N. Abrams, 1987

American Abstract Artists. *The World of Abstract Art,* New York: George Wittenborn, 1958

Ashton, Dore. *The New York School: A Cultural Reckoning.* New York: Viking Press, 1973

Baur, John I.H., *New Art in America.* New York: Praeger, 1957

Blesh, Rudi. *Modern Art USA.* New York: Alfred A. Knopf, 1956

Brown, Milton W. *American Painting from the Armory Show to the Depression.* Princeton: Princeton University Press, 1955

Calas, Nicolas. *Art in the Age of Risk and Other Essays.* New York: E.P. Dutton, 1968

Chassman, Neil A., *Poets of the Cities: New York and San Francisco, 1950–1965.* New York: E.P. Dutton, 1974

Contemporary Art — 1942–72. Albright-Knox Art Gallery, Buffalo, New York. New York: Praeger Publishers, 1972

Cummings, Paul. *Artists in Their Own Words.* New York: St. Martin's Press, 1979

Friedman, Bernard H. *School of New York, Some Younger Artists.* New York: Grove Press, 1959

Geldzahler, Henry. *American Painting in the Twentieth Century.* New York: New York Graphic Society, 1965

_____. *New York Painting and Sculpture: 1940–1970.* New York: E.P. Dutton, 1969

Greenberg, Clement. *Art and Culture: Critical Essays.* Boston: Beacon Press, 1961

Gruen, John. *The Party's Over Now — Reminiscences of the Fifties — New York Artists, Writers, Musicians and Their Friends.* New York: Viking Press, 1967, 1972.

Hess, Thomas B. *Abstract Painting: Background and American Phase.* New York: Viking Press, 1951

Hess, Thomas B. and John Ashbery. *The Avant-Garde.* New York: The Macmillan Company, 1968

Hunter, Sam. *Modern American Painting and Sculpture.* New York: Dell Publishing Company, 1959

_____. *USA Art Since 1945.* New York: Harry N. Abrams, 1958

Hunter, Sam and John Jacobs. *Modern Art From Post-Impressionism to the Present.* New York: Harry N. Abrams, 1976

Janis, Sidney. *Abstract and Surrealist Art in America.* New York: Reynal and Hitchcock, 1944

Kootz, Samuel M. *New Frontiers in American Painting*. New York: Hastings House, 1943

Kuh, Katherine. *The Artist's Voice; Talks with Seventeen Artists*. New York: Harper and Row, 1962

Mellow, James R. *New York: The Art World: Arts Yearbook 7*. New York: Art Digest Inc., 1964

Motherwell, Robert and Ad Reinhardt, eds. *Modern Artists in America*. New York: Wittenborn Schultz, 1951

Nordness, Lee. *Art U.S.A. Now Vol. 1 & 2*. New York: Viking Press, 1962

O'Doherty, Brian. *Object and Idea — An Art Critics Journal 1961–1967*. New York: Simon and Schuster, 1967

O'Hara, Frank. *Art Chronicles: 1954–1966*. New York: George Braziller, 1975

Rodman, Selden. *Conversations with Artists*. New York: Devin-Adair, 1957

Rose, Barbara. *American Art Since 1900*. New York: Praeger, 1967

_____. *Readings in American Art Since 1900*. New York: Praeger, 1968

Rosenberg, Harold. *The Anxious Object: Art Today and Its Audience*. New York: Horizon Press, 1966

_____. *The Tradition of the New*. New York: Horizon Press, 1959

Sandler, Irving. *The Triumph of American Painting: A History of Abstract Expressionism*. New York: Icon Editions/Harper & Row, 1970

_____. *The New York School*. New York: Harper & Row, 1978

Schimmel, Paul. *Action Precision — The New Direction in New York 1955–60*. Newport: Newport Harbor Art Museum, 1984

Seitz, William C. *Abstract Expressionist Painting in America*. Washington, D.C.: Howard University Press, 1983

Steinberg, Leo. *Other Criteria: Confrontations with Twentieth-Century Art*. New York: Oxford University Press, 1972

Tompkins, Calvin. *The Bride & the Bachelors: The Heretical Courtship in Modern Art*. New York: Viking Press, 1965

_____. *Off The Wall — Robert Rauschenberg and the Art World of Our Time*. New York: Doubleday & Company, 1980

Tuchman, Maurice. *The New York School — The First Generation*. New York: New York Graphic Society, 1972

Richard Pousette-Dart